Painting
Coastal Scenes

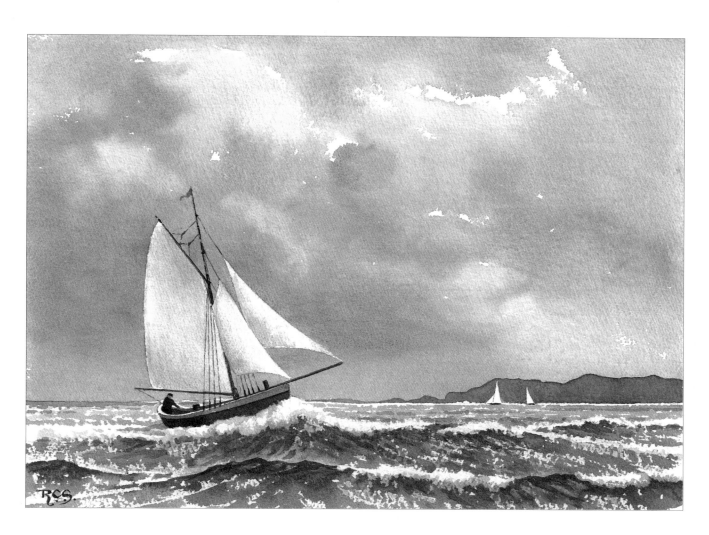

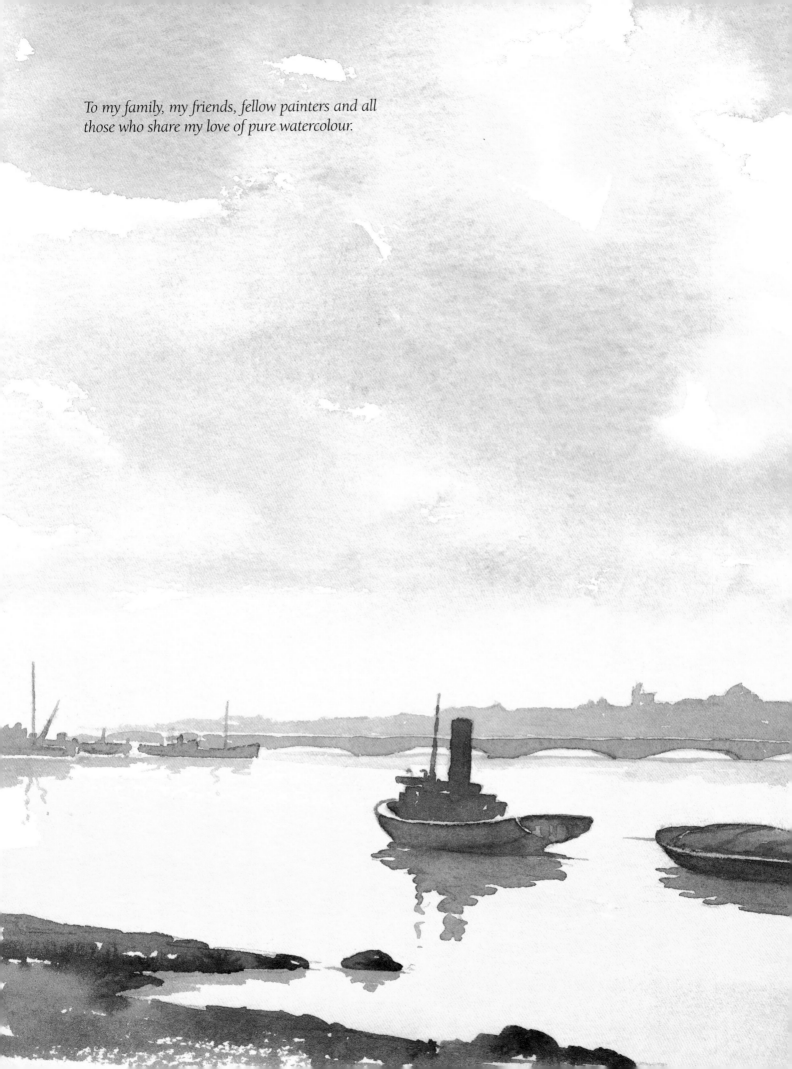

To my family, my friends, fellow painters and all those who share my love of pure watercolour.

Painting
Coastal Scenes

RAY CAMPBELL SMITH

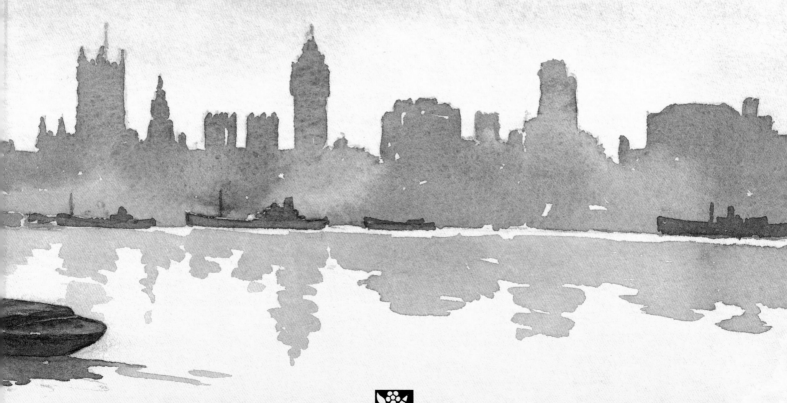

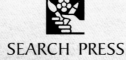

SEARCH PRESS

First published in Great Britain 2003 as 'Painting Estuaries &
Coastal Scenes'.

Search Press Limited
Wellwood, North Farm Road,
Tunbridge Wells, Kent TN2 3DR

Reprinted 2004, 2005, 2007

ISBN 10 - 1 903975 41 7
ISBN 13 - 978 1 903975 41 1

The Publishers and author can accept no responsibility for any
consequences arising from the information, advice or
instructions given in this publication.

Suppliers
If you have difficulty in obtaining any of the materials and
equipment mentioned in this book, please visit the Search
Press website for details of suppliers: www.searchpress.com

Alternatively, you can write to the Publishers at the address
above, for a current list of stockists, including firms which
operate a mail-order service, or you can write to Winsor &
Newton requesting a list of distributors:

Winsor & Newton, UK Marketing, Whitefriars Avenue,
Harrow, Middlesex HA3 5RH

Publishers' note

All the step-by-step photographs in this book feature the
author, Ray Campbell Smith, demonstrating how to
paint estuaries and coastal scenes in watercolour.
No models have been used.

There is a reference in this book to sable and other animal
hair brushes. It is the publishers' custom to recommend
synthetic materials as substitutes for animal products
whenever possible. There are a large number of brushes
made from artificial fibres available, and these are just as
satisfactory as those made from animal fibres.

*I should like to acknowledge the invaluable professional
help I have received from Roz Dace, Editorial Director,
and Alison Howard, Editor. I also wish to thank
Susannah Baker for converting my scrawl into perfect
typescript and, as ever, my wife Eileen for her unfailing
encouragement and support.*

Page 1:
Choppy Sea
*The white sails of the foreground boat register strongly against the
grey sky and are balanced by the dark land form on the right.
A broken wash technique suggests the foam in the waves.*

Pages 2/3:
Thames Estuary at Westminster
*The strong handling of the foreground contrasts with the softer
treatment of the distance to indicate recession.*

Opposite:
Blackwater Estuary
*The deep tones of the boats, buildings and shoreline contrast with
the very pale tones of the water and help to make it shine.*

Introduction:
Fishing Boats at Anchor
*To capture the impression of the crisp sunlight I emphasised tonal
contrasts, particularly in the foreground boats.*

Contents

Introduction

The margin between land and sea has fascinated and inspired artists over the years, and retains its unique magic. This is in part due to the wonderful variety of landscape scenery, resulting from differences in the rock strata that make up the coastal fringe: the rugged shapes carved out by the sea from granite and other hard, old rocks; the smoother and more vertical white chalkland cliffs; the moody saltings typical of low-lying stretches of sand or clay, and more. Where ranges of hills run out to the sea, the spectacular beauty of headlands of towering cliffs also appeals to the perceptive artist.

In many areas the coastal scene has been affected greatly, for good or ill, by the hand of man. The cosy, stone-built villages and harbours of the West Country have a particular charm; one of these attracted the colony of artists which became known as the Newlyn School. The elegant Georgian façades and Victorian promenades and piers of some South Coast resorts have a very different, but equally strong, appeal. The massive warehouses and docks of the great ports, and the stark outlines of the power plants and factories of industrial coastal towns, present yet another challenge, but one to which the imaginative artist can respond with paintings full of atmosphere and feeling. I shall look at all these, and consider how to capture their essence, then give them form and substance in watercolour..

I shall also be dealing with estuaries, the tidal reaches where rivers widen to meet the sea. Here, too, the scenery is shaped by the underlying geology: rugged mountains of hard, old rocks; smoother downlands of softer rocks; flat plains of alluvial deposits. To do these justice, you should study the elements of the landscape: skies; hills; mountains; fields; trees; hedgerows; buildings; harbours; piers; boats and, of course, water. Handled competently, water can bring light and life to the dreariest landscape, and serve the useful function of linking the sky to the scene below. The clarity and transparency of watercolour is uniquely suited to capturing its shine and movement: you should strive to preserve its wonderful properties by the correct use of technique, avoiding over-working, over-elaboration and alteration.

As you work through this book, you might like to copy some of the paintings, or work from my sketches to develop your own interpretation of the scene. Do not worry about accuracy as this may lead to tightness; concentrate on capturing atmosphere with full, clear washes. With practice this should help you to develop a bolder, looser and more confident style.

Ray Campbell Smith

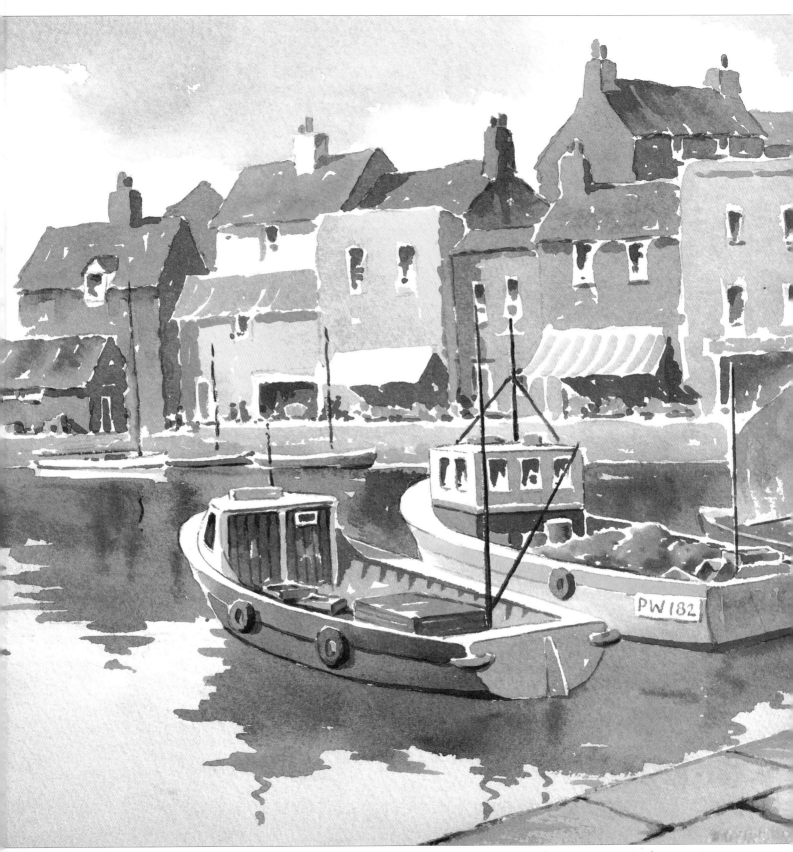

Fishing Boats at Anchor

Materials

PAPER

I am discussing paper before paint because I believe strongly that choice of paper has a greater influence on results than any other factor. Some papers flatter work and seem to respond positively to good brushwork, while others have the opposite effect. Quality, and therefore expense, come into the equation: the best papers are the expensive ones made from pure cotton rag. The best of the wood pulp papers, however, are excellent and represent good value for money.

Another factor to consider is the type of surface. There are three main surfaces: smooth (also known as HP or hot-pressed); rough and Not (not hot-pressed), which is midway between rough and smooth. Not is the most widely used and suits most watercolourists. Smooth is often used for very detailed work, and sometimes for line and wash, but I do not find it ideal for watercolour painting. Rough has many advantages, especially for landscape work. It has real 'tooth', and its texture greatly facilitates techniques such as broken wash and dry brush work.

Weight of paper is also important. Thick, heavy papers are far more resistant to cockling, the undulating effect that occurs when liquid washes are applied. Cockling can cause all sorts of difficulties: liquid washes tend to drain off the ridges and collect in the valleys, leading to uneven drying, cauliflowering and other horrors. I have used 640gsm (300lb) rough paper throughout this book, but a lighter weight, less expensive grade can be used if you stretch it, a simple process described on page 21. It is well worth experimenting with types and grades of paper to find one or two which really suit your work.

All the paintings in this book are approximately quarter Imperial size, 283 x 280mm (15 x 11in).

DRAWING TOOLS

I usually choose a 2B pencil, but almost anything will do, and I sometimes use a fibre-tipped pen, a technical pen or even a fountain pen. If I feel the tones need careful consideration, I often add watercolour washes of dilute lamp black for the shadows.

A selection of watercolour papers

PAINTS

Well-meaning friends and relatives may present budding artists with elaborate paintboxes containing dozens of colours, but these only cause confusion. A simple paintbox with good, deep mixing wells and space for twelve or so pans is a far better choice.

I am often asked if it is worth paying a little more for artists' quality, rather than students' quality paints. I believe artists' quality is better: the colours are clearer and fresher, and can give your work an extra lift. Watercolour is not as lavish with pigment as some media, so the difference in cost per painting cannot be great. As to whether pans or tubes are best, paint in pans is readily accessible, but paint in tubes is more liquid and responsive. My solution is to combine the two: I squeeze paint from tubes into my pans and have fresh, responsive paint conveniently to hand. Nothing is lost or wasted, and I use far less pigment than if I were to squeeze paint on to a palette and wash it off after each session. This method has its critics, but I have used paint in this way for many years with no problems whatsoever.

You will need more mixing space than the average paintbox provides. In the field, I use a large, lightweight plastic palette. In the studio, where weight is not a problem, I use nothing more elaborate than several white kitchen plates.

BRUSHES

Kolinsky sable brushes are widely regarded as the best, both for their springiness and for their wash-holding properties. They are extremely expensive, however, and likely to become more so. Fortunately, there are good alternatives, both for those who want something cheaper and for those who object to the use of sable on moral grounds. Some synthetic brushes are excellent value, as are those which contain a mixture of sable and other fibres.

It makes sense to start with just a few brushes, and add more as you feel the need and become more experienced. The size you choose will naturally depend on the scale of your work. As a rough guide, an artist who normally uses the popular quarter Imperial size paper 283 x 280mm (15 x 11in) would include a large brush for skies and other broad areas – perhaps a 25mm (1in) flat or a 25mm (1in) mop – and three rounds: Nos.4, 8 and 12 should be adequate in the early stages. Large brushes make it difficult to include fiddly detail, and will encourage you to go for the broad effect. Smaller brushes may seem more manageable and you may be tempted by them, but if you stick to the larger sizes your work will become freer and bolder.

OTHER EQUIPMENT

Paper towel or rag Use this for wiping and blotting.

Masking tape Use this to attach paper to your drawing board, and to preserve large areas from broad washes.

Putty eraser This does less harm to the paper than a rubber or plastic eraser.

Craft knife Use this to sharpen pencils, and also to scratch out highlights.

Masking fluid This is dealt with in more detail on page 20.

Easel If you prefer to use an easel in the studio, a sturdy wooden one is best. For outdoor work, the best choice is a lightweight metal easel.

Plastic palette In the field, I use a large, lightweight plastic palette.

Drawing board I use a piece of stout plywood to support my paper.

Folding stool This is ideal if you prefer to work, as I do, with your drawing board on your lap.

Gummed paper strip Use this for stretching paper.

Water containers You will need two: one for clean water and one to rinse brushes.

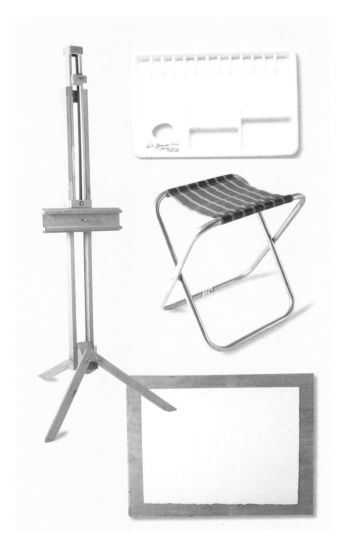

TRAVELLING LIGHT

I like to travel light, and all my outdoor painting equipment fits in a small canvas bag.

SKETCH BOOKS

Very few artists have the confidence and ability to paint direct from their subject, so a sketch book is essential. It enables you to examine your subject in depth and make graphic notes on elements which deserve emphasis. It also makes it possible to experiment until a composition is really pleasing. Studying a subject in depth, no doubt changing your mind as you do so, develops your response to the subject in a way which could not happen if you went straight in with the brush.

A sketch book also allows you to record scenes on those frequent and frustrating occasions when there is not enough time to paint on the spot. Most experienced painters develop their own shorthand to record colours, textures and so on, and these notes help to bring the scenes vividly to life when they are back in the studio. A sketch book is the perfect place to record subjects which may come in useful in the future: people in various poses; fleeting effects of light; cloud formations; buildings; boats – the list is endless. Some landscape subjects benefit greatly from the inclusion of a figure, to provide human interest, a focal point or perhaps scale. The chances of a suitable model appearing at the right time are slim, but a well-stocked sketch book can fill the gap.

The important thing is to record the essentials of your chosen subjects, work out the tone values, decide upon the treatment and of course, the composition. If you do this, your sketch book will soon become an essential and trusted friend.

Choice of sketch book is a personal matter. Some people find the pocket-sized type convenient, while others prefer something larger. I use both: a pocket sketch book which goes everywhere with me to capture the fleeting moment, and a book with larger, loose leaves which I use for planning a painting.

Children Playing

In summer, beaches become playgrounds for holidaying families and I like to sketch children having fun with bucket and spade. These are a few examples from my sketchbook, some of which I have used in seaside paintings.

Using colour

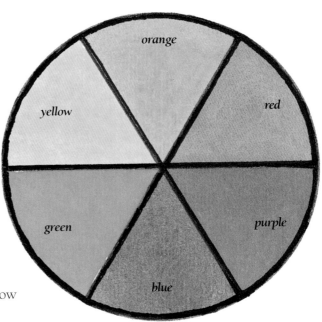

Choice of colour needs careful thought, and some knowledge of basic theory helps us to use colour more effectively. The simple colour wheel is a good place to start.

Three of these colours, red, yellow and blue, are known as the primaries, and cannot be made by mixing any other colours. Between them on the wheel are the secondaries: orange, green and purple. These are produced by mixing the two adjacent primaries: for example, red and yellow make orange. These secondaries can vary greatly according to the proportions of the two primaries used. Mixing a lot of yellow with only a touch of red will produce a warm yellow rather than a true orange.

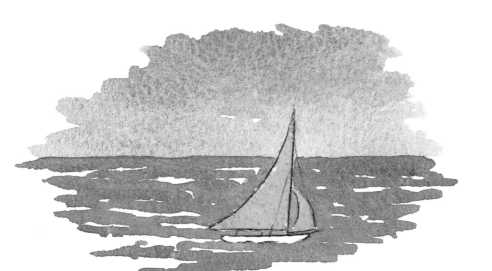

Secondary colours

As you have seen, these can vary considerably according to the proportions of the two colours used to mix them, as shown by the two very different variations of orange.

Tertiary colours

These are produced by mixing the three primary colours, or a primary and a secondary colour. Combining the primaries in roughly equal proportions tends to result in muddy browns and greys. If one of the three is allowed to dominate, the results are very different and subtle, and often beautiful colours appear. As your experience grows, you will be able to mix these fascinating colours at will, to the enrichment of your work.

Complementary colours

This simply means colours that are opposite each other on the colour wheel, but they have real significance for artists. Placed side by side in a painting, they make a powerful impact. The example most frequently cited is the figure dressed in red against a verdant landscape, but the orange sail of this example against the Mediterranean blue of the sea makes an equally strong impact.

MIXING GREENS

The colour green needs particular thought and care. Made-up greens tend to be harsh as well as too cool, because they contain too much blue. If used for landscape work, they can make the countryside look thoroughly artificial. Olive green is the most suitable made-up green, but even this can benefit from the addition of a little yellow. For landscape work something softer and warmer (with more yellow) is needed, which is why most experienced painters prefer to mix their own greens.

Lawn green

A mix of cadmium yellow (a true yellow) and Winsor blue (a rather greeny blue), makes a fairly bright green, suitable for well-kept lawns.

Meadow green

Substituting raw sienna for cadmium yellow and mixing it with Winsor blue produces a more natural colour suitable for meadow grass.

Top: *raw sienna, burnt sienna, light red, French ultramarine, Winsor blue **
Middle: *alizarin crimson, Payne's gray, raw umber, burnt umber, cobalt blue*
Bottom: *cadmium yellow, cadmium orange, cadmium red*

* Winsor blue is no longer manufactured, but like many painters, I still have a supply. To mix greens, the new Winsor blue-green shade may be substituted, but you will need to use a little less yellow, or raw sienna.

THE LIMITED PALETTE

You may have heard art teachers praising the virtues of the limited palette. In this context, 'palette' simply means a range of colours. The argument for limiting your palette is that, if you use only a small number of colours, you become familiar with their individual properties, and your paintings will 'hang together' in a way which is simply not possible if you use every colour in the spectrum.

My limited palette for landscape and marine subjects consists of the colours on the top line of the colour chart, left. Sometimes, if the painting requires it, I add one or two colours to my basic palette (centre left). For work which features sunnier climes, I often add the cadmiums (bottom left).

If you have not yet decided which colours work best for you, it is a good idea to adopt the limited palette of an artist whose work you admire. As you gain in experience, you will undoubtedly make adjustments to suit your developing style.

COLOUR TEMPERATURE

This expression refers to the warmth or coolness of the hue. Reds and yellows, the colours of flame and fire, are at one extreme and blues and greys, the colours of shadows falling on snow and ice, are at the other. An understanding of colour temperature is vital in landscape painting, in which colours are warmest in the foreground and coolest in the distance, the 'blue, remembered hills' being an example. Correct use will make foregrounds come forward and backgrounds recede into the distance, just as they do in nature.

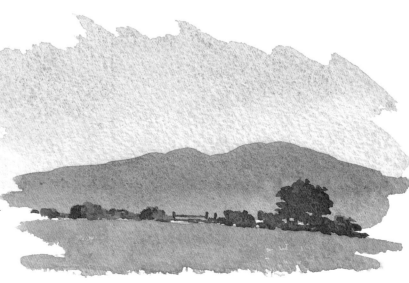

EXTENDED PALETTE

Your colour palette will naturally vary according to the demands of your subject. The range of colours which serves well for the subtle tones of the English countryside may not be able to do justice to the brighter tints of Mediterranean and tropical climes. Strong sunlight on colour-washed walls, for example, may well require the cadmiums – red, orange and yellow – and I always take these with me on trips abroad.

As for the blues, French ultramarine serves well for the intense colour of Mediterranean and tropical skies, and it almost always pays to warm it a little towards the horizon, and I did in the painting opposite. I made the most of variations in the colours of the buildings, for the sake of interest, and also emphasised the deep tones of the shadows to strengthen the impression of sunlight. The slanting shadows cast by the shop awnings indicate the direction of the strong sunlight.

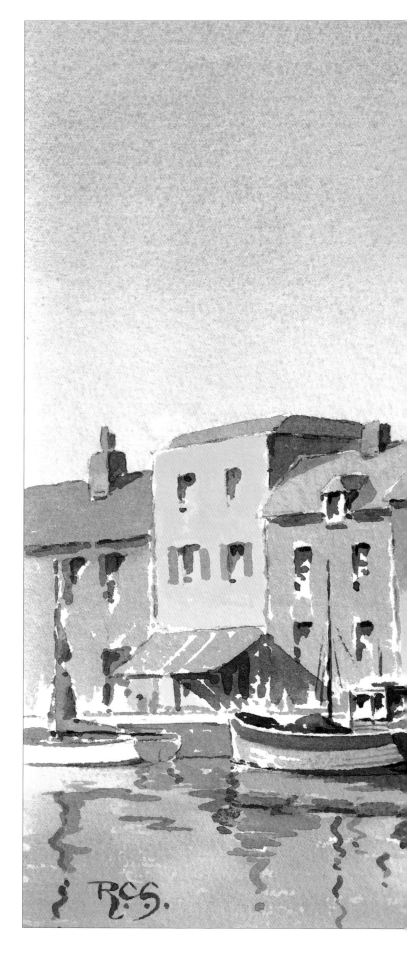

Mediterranean Waterfront

The reflections in the harbour water were indicated fairly loosely, with the edges indented to suggest gentle ripples.

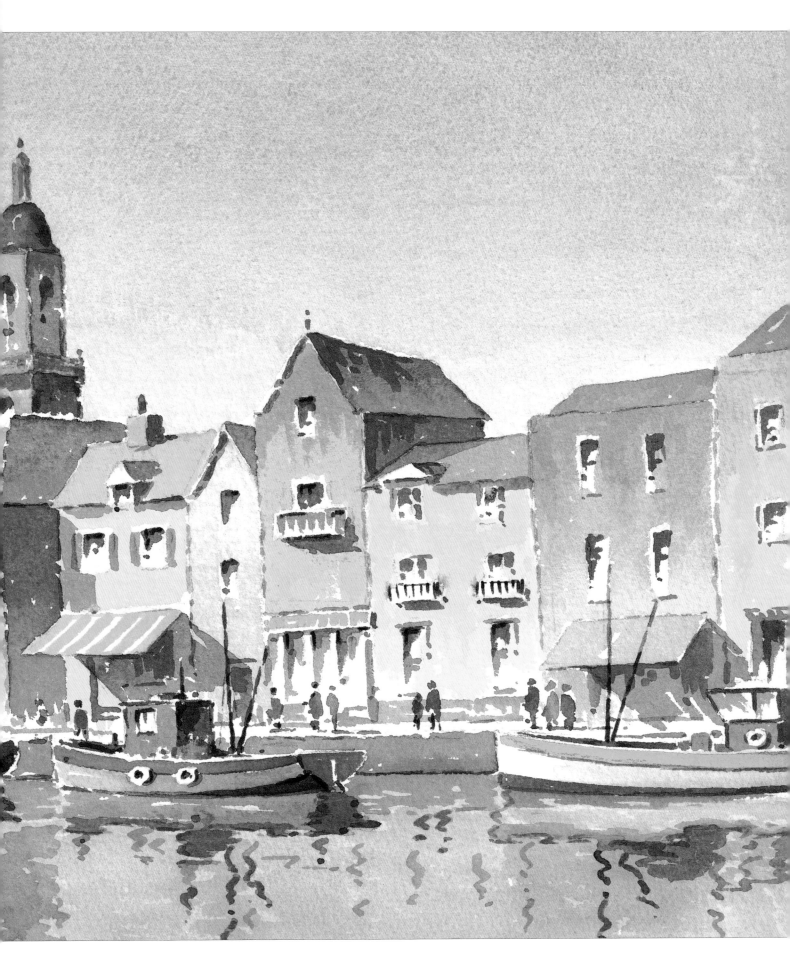

Techniques

The beauty of watercolour lies in its transparency and clarity, but these wonderful properties can easily be lost through over-working, alteration or faulty technique. Preserving the vital freshness of the medium means paying close attention to correct technique. All too often, art pundits seek to emphasise their liberated philosophy by declaring that there are no rules in painting, or that if there are, they are there to be broken. Let me put the record straight: you break the rules of watercolour technique at your peril, and if you do, you are likely to produce muddy paintings from which the true beauty of the medium has departed. Stick to the rules, and you will produce fresh, clear and expressive washes. How you use these washes is another matter: if you have something revolutionary to say, by all means depart from convention.

The wash is the basis of all watercolour painting, and mastering it must be the first concern. Inexperienced painters often assume that washes are only for large areas, and that for smaller passages it is safe to paint straight from the pan. It is far better to use the wash technique for even the smallest areas, to ensure that they too are clear and fresh. The simplest type of wash, the flat wash, is used when an area, of whatever size, must be a smooth, even colour all over. I usually work with my board at an angle of about 15° from the horizontal, which greatly facilitates the application of a wash over a large area. Beginners do not always achieve a smooth result, usually because they work too slowly and the pigment is not absorbed evenly. This results in a stripy effect, which is more pronounced on absorbent papers. The remedy is either to speed up the rate of work or to dampen the whole area before applying the wash. If you do this, remember to make the wash a little stronger to compensate for the diluting effect of the damp surface.

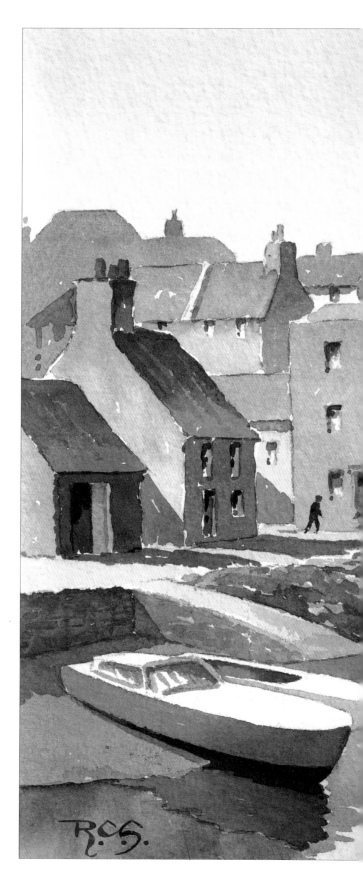

West Country Jetty

The sky in this painting is a pale, variegated wash of raw sienna with a touch of light red blending softly into a hint of Winsor blue. The same wash, with a little added raw sienna, was used for the sky reflection in the water below. French ultramarine with a little light red was used for the far shore, and a stronger mix of the same colours for the shadows and stone jetty. For the houses, I used various blends of pale raw umber, light red and French ultramarine, with a stronger mix of French ultramarine and light red for the shadows and the stone jetty. I used raw sienna with a little Winsor blue for the marine algae on the jetty and the outcrop of natural rock. The reflections were wet-in-wet blends of the colours used above, with indented edges to suggest the gently rippling surface of the water. I left three small triangles of untouched paper to indicate distant sails.

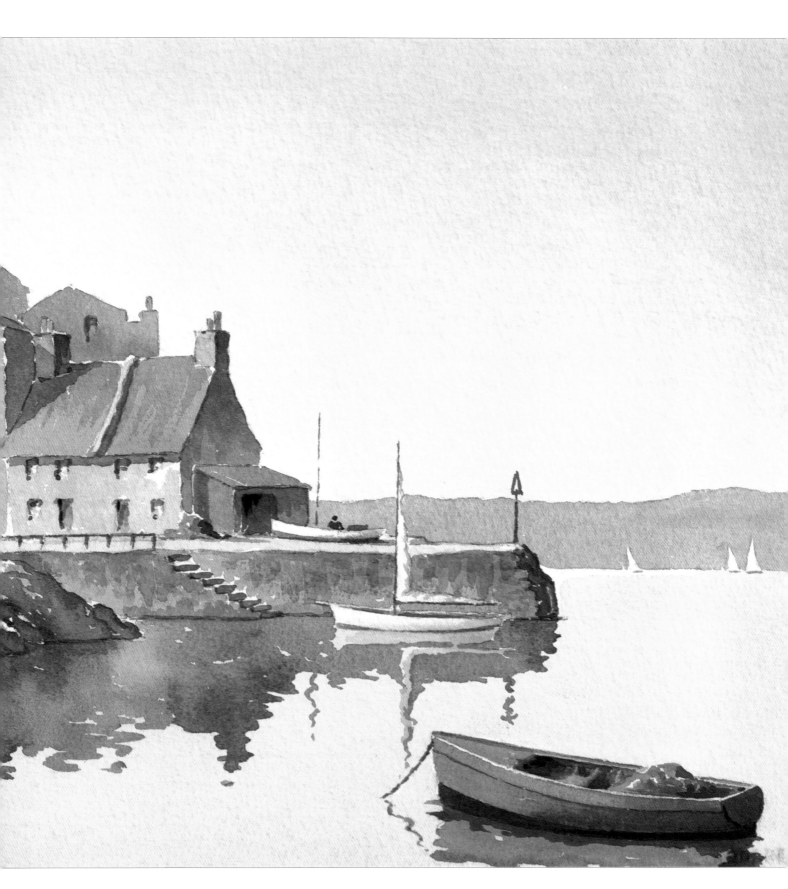

WASHES

To prepare a wash, pour a little water – the amount will depend on the area to be covered – into a mixing well, add pigment and mix. To avoid making it too strong, add pigment a little at a time, particularly the powerful staining colours such as Winsor blue. The amount of paint needed will depend on the tone you require. You can add one, two or three colours to obtain the desired hue, but if you use too many, freshness will be the first casualty. Remember that watercolour fades appreciably on drying, so allow for this when you prepare your washes.

The following examples should help you to develop the techniques you will need to paint perfect washes.

Simple flat wash

Prepare a pool of colour of the desired shade and strength, then apply a horizontal stroke with a large fully-laden, large brush right across the top of the area to be covered. The tilt of the board makes a bead of liquid gather at the lower margin of the stroke, but this is taken up by the next stroke. This is repeated all the way down the area to be covered. I always apply horizontal strokes from alternate sides so the pigment is spread more evenly across the paper.

Graded wash

The graded wash is one in which the colour gradually pales as you work downwards on the paper. To achieve this result, prepare two washes: the first of the chosen colour and the second of pure water. After the first horizontal stroke or two, begin to pick up an ever-increasing proportion of pure water so that the liquid in your brush becomes progressively more dilute and paler. If it has been judged accurately, there will be a smooth transition from dark to light down the page.

Variegated wash

This is very similar to the graded wash, except that two pools of different colour are prepared. Use the same technique as before, but begin to pick up an increasing proportion of the second wash instead of water. A good result is a smooth, even transition from the first colour into the second. It is easy to see how useful the variegated wash can be for depicting clear skies in which the blue gradually merges into a warmer colour towards the horizon.

Broken wash

This useful technique demands practice but is worth the effort. The brush is dragged rapidly across the surface of the paper, leaving chains of tiny white dots where it misses the indentations. It is important to gauge how much to load the brush: if it is too heavily loaded, the wash will cover these depressions. It is easier to obtain the desired effect if the brush is held very flat, almost horizontally to the paper, and rough paper helps. This wash is useful for suggesting foreground detail such as shingle or grass, though some added detail is often necessary. If the white dots are likely to look too startling, a pale flat wash can be applied across the area first.

Wet-in-wet

This is probably the most exciting technique, and watercolourists should add it to their repertoire as soon as possible. It produces soft, ethereal images, allowing subtle effects like mist and fog to be captured. If the rules are followed, creating these soft, atmospheric effects is surprisingly easy. The simplest form of the technique is a soft-edged mark. The paper is moistened first, either with plain water or a pale wash of colour. While it is still moist, a darker colour is applied with a single brush stroke, and this blends with soft edges into the background wash. It is vital that this stroke is less liquid than the background wash or cauliflowering will occur.

Misty woodland

A pale wash was applied over the whole paper, and the distant trees were put in. The paper was at its wettest in the early stages, so the outlines are very soft and the colours pale. It was marginally less wet when the nearer trees were put in, so their edges are a little firmer, though still soft-edged, and the colours a little darker. The wetter the paper, the softer the image; the drier the paper, the more definite, until, on completely dry paper, the image is hard-edged. If the paper is too wet, the second applied mark or wash will merge with it and will be virtually lost. Skill in judging the degree of dampness required for different effects will come with practice. Both washes should be prepared in advance and the work carried out quickly before the paper dries. The second wash should be less liquid than the moist paper to which it is applied or cauliflowering will result and the effect will be ruined.

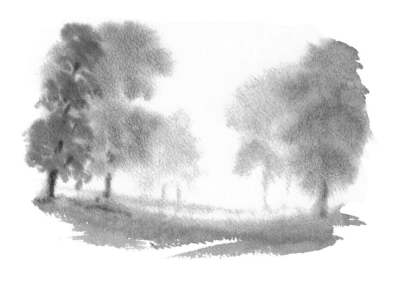

FURTHER TECHNIQUES

Dry brush work

A variant of the broken wash is generally referred to as dry brush work. Here, as the name suggests, the brush should be less wet than for the broken wash, but the roughness of the paper is still used to help to indicate texture. This technique is useful for suggesting the rough surface of objects including weathered stone and tree bark. The amount of wash on the brush is critical: too much and the effect is lost; too little and the marks look muddy.

Masking fluid

The shapes of the gulls were painted with an old brush in diluted masking fluid. When it was quite dry, the deep grey wash was applied all over. When this in turn was completely dry, the dried masking fluid was removed gently with the tip of a finger, leaving the white shapes of the gulls. Masking fluid plays havoc with brushes, so use only cheap or worn-out ones.

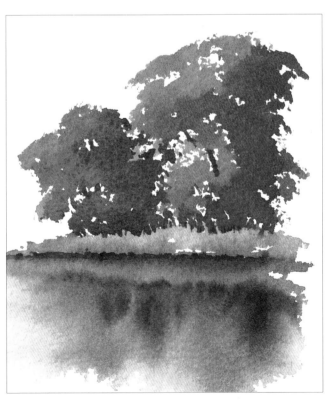

Soft-edged reflections in water

For this sketch, I painted some trees lining the water. I prepared several washes of different colours and strengths: pale green for the sunlit foliage and grass; deeper green for the shadows, and so on.

I moistened the whole area of water with a very pale wash, similar in colour to the sky, and began to drop in vertical strokes, wet-in-wet, of the prepared washes. I worked from light to dark, beginning with the lighter tones and ending with the deeper. As the base wash had begun to dry by this point, the darker marks are more precise, though still soft-edged. It is vital to work fairly quickly, so all is finished before the paper dries.

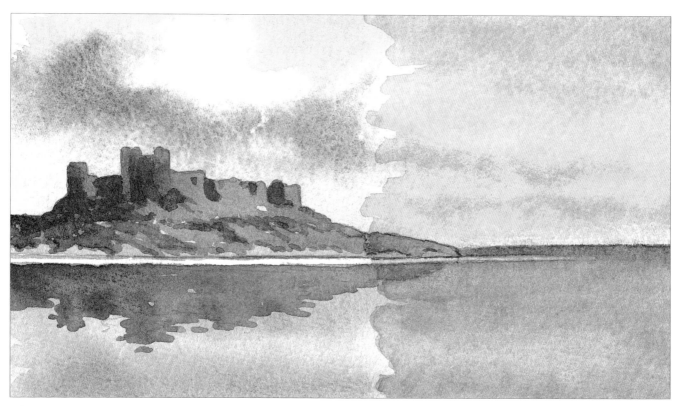

Glazing

This technique, shown above, is really an extension of the flat wash. It is simply the addition of a transparent wash, usually pale, to an area you have already painted. This area may be a certain passage in your painting or the whole painting. If, for example, you wish to give a tree in your landscape a more autumnal look, you may apply a wash of burnt sienna to that area, but if you want to impart a warm evening glow to the entire subject, then you may apply the warm wash over the whole paper. Work quickly, with a light touch, to avoid disturbing the under-painting.

STRETCHING PAPER

Watercolour paper of less than 425gsm (200lb) in weight really needs to be stretched if cockling is to be avoided when liquid washes are applied. This is the method I use:

1. Immerse your paper in pure water for about five minutes.
2. Pick up the paper by one corner to allow the excess water to drain off, and lay it on a drawing board or other flat surface.
3. Smooth away any air bubbles with a soft cloth, taking the utmost care to avoid damaging the paper's surface, which is very vulnerable when wet.
4. Tape the paper firmly to the board, using brown gummed paper strip, allowing the strip to overlap the paper by not less than 13mm (½in).

The following day the paper will be taut and dry, which will minimise any possibility of cockling when liquid washes are applied. You can then work on the paper on the board, only cutting it free when you have finished your painting.

Aerial perspective

The colours and tones of the landscape change as they recede into the distance, and successful painters will always capture these effects in their work.

Colour becomes progressively cooler with distance, until the far hills may appear to be a soft blue-grey. By contrast, the foreground colour will be much warmer, with hints of reds, oranges and yellows. Even the grass will be a warm green. Then there is tone or, in common parlance, lightness and darkness. Objects become increasingly pale with distance and, when painted in this way, help to capture the feeling of recession. Tone variation also decreases with distances, There are significant differences between lights and darks in the foreground, but there may be none in the far distance, when a flat wash of blue-grey may well accurately represent the far hills.

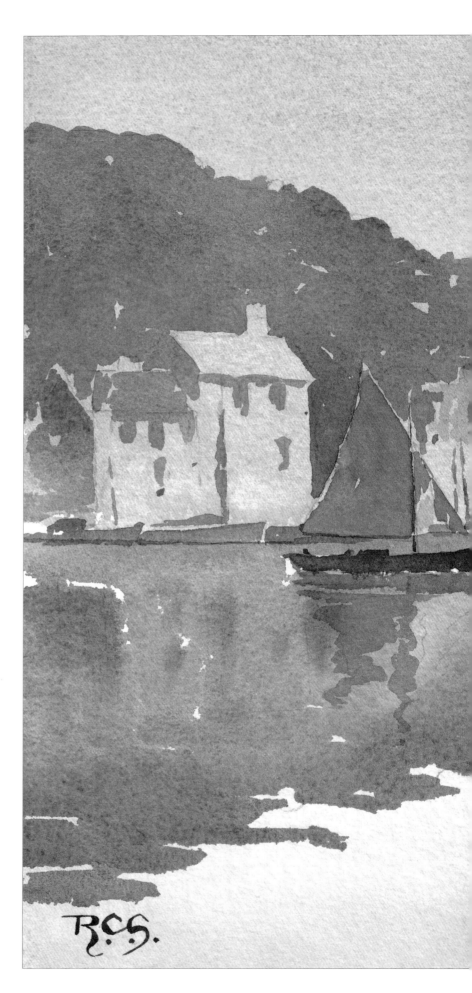

The Harbour

The deep tones of the foreground boat and harbour wall contrast with the paler tones of the background to create a strong impression of aerial perspective.

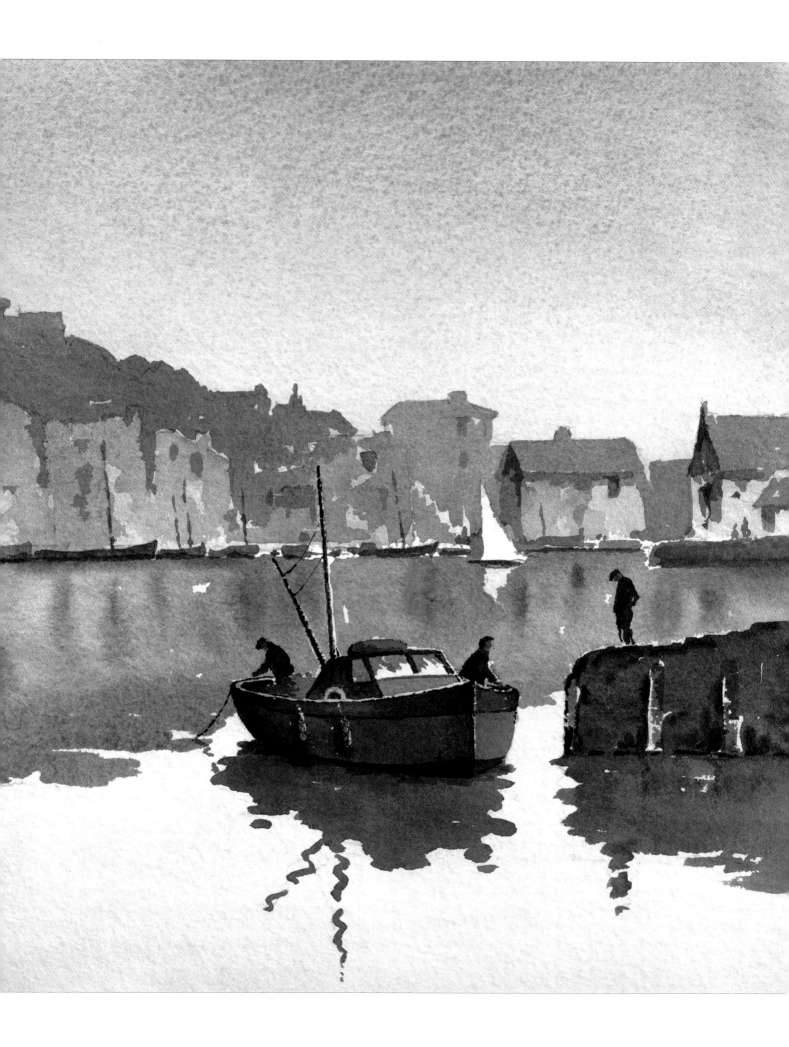

Skies

The sky plays a fundamental role in all landscape subjects, not least because its character affects every other part of the scene. This is particularly true when the scene consists mainly of water, which is more responsive than dry land to the tones and colours of the sky.

Skies can be divided into two main categories: clear and cloudy. Clear skies vary enormously according to the climate, season and time of day. Cloudy skies are similarly affected, but the type of cloud plays an even more dominant role. The main categories are *cirrus*, *cumulus*, *stratus* and *nimbus*, and there are also intermediate categories such as *cumulo-nimbus* and *alto-stratus*. Cirrus, the high, fleecy white clouds, are not an ideal subject for bold watercolour techniques and I tend to avoid painting them, but other cloud forms can be substituted for a far more pleasing effect. There is no need to reproduce exactly what you see.

The variegated wash (see page 18) is ideal for painting clear skies. It allows the cool colours of the upper sky to merge into the paler, warmer tones just above the horizon. In general, colours are warmer in hot climates, and in the evening rather than the morning. French ultramarine serves well for the intense blue of Mediterranean or tropical skies, while cobalt or Winsor blue are often more suited to temperate climes.

Clear sky

The lower sky, above the horizon, is usually paler and warmer in colour. Here, the addition of a little raw sienna, perhaps with a touch of light red, may do the trick.

Hot weather haze

In hot weather, there may be a purplish heat haze, for which a mix of French ultramarine and light red may be used. There are no hard and fast rules: it is simply a matter of careful observation.

Cumulus clouds

These are the billowing variety with high-domed crests and fairly level bases. They respond well to bold watercolour techniques.

Stratus clouds

These are the flat layers of water vapour which may cover the whole sky, or just part of it.

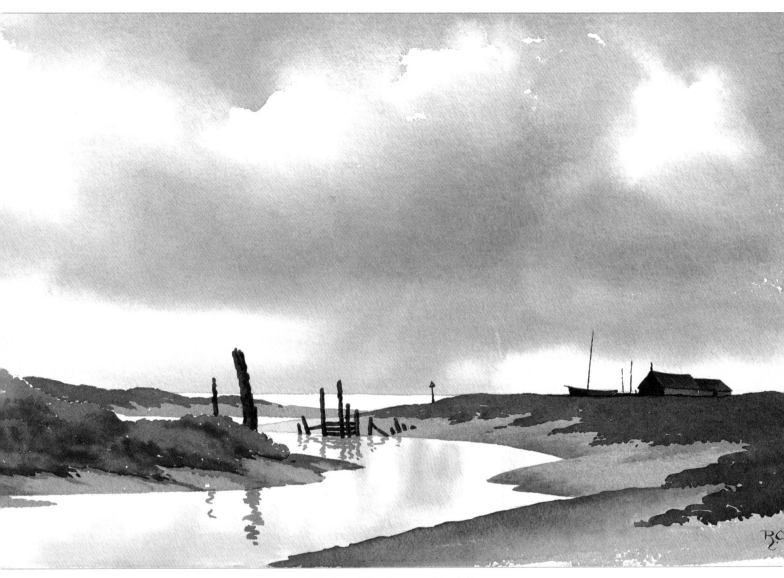

Nimbus Clouds over Norfolk

I have painted this sea inlet several times in varying weather conditions, and on this occasion the lowering storm clouds added to its brooding atmosphere. There were breaks in the heavy clouds, and I used one of these to silhouette the boats and sheds. I began by preparing three washes: dilute raw sienna, a mixture of French ultramarine and light red and thirdly, Payne's gray. I applied the pale wash for the breaks in the clouds and for those areas where the clouds caught the fitful light. I then applied the two deeper washes in quick succession for the dark clouds, allowing much blending to take place but keeping some hard edges. Finally, I added a couple of diagonal brush strokes, wet-in-wet, to indicate a distant rain squall.

SUNSETS

Spectacular sunsets have an irresistible appeal, and artists feel compelled to try to capture something of their radiant colour in paint. This is understandable, but can lead to frustration and disappointment. Sunsets with glowing pinks, oranges, purples and greens may look breathtaking in nature but will simply look gaudy on watercolour paper.

There are two reasons for this: firstly that watercolour is a subtle medium, at its best it is used with restraint to capture atmospheric effects, and at its worst when pushed to extremes in an attempt to reproduce the brilliant, sometimes harsh colours of the real world. The second reason is that clashing sky colours, even when gently handled, rarely produce pleasing results in watercolour. It is best to leave powerful colours to the oil painters and operate within the gentler colour range of the watercolour medium. Resist also the temptation to use all the colours of the rainbow, and concentrate instead on related warm hues for watercolour sunsets.

The most effective way to make a watercolour passage shine is to place strong darks alongside, as shown in the example below and the painting opposite. Just as deep-toned river banks make the pale water between them appear to shine, so dark contrasts will by comparison seem to make a sunset glow.

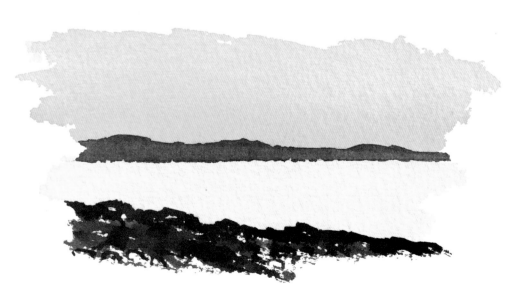

Dark banks make the river shine by contrast

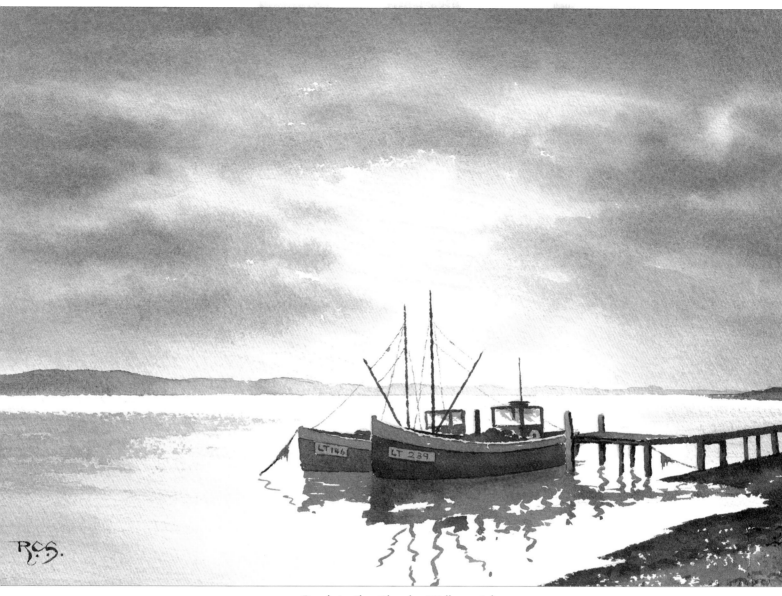

Break in the Clouds, Walberswick

I wanted to capture the setting sun's radiance, so I began with three liquid washes: very pale raw sienna for the brilliance in the sky; light red with a touch of French ultramarine for the warm edges of the clouds, and a stronger mix of French ultramarine with a little light red for the deeper-toned areas of cloud. Working quickly, I established the areas of radiance, then used my second wash for the warm cloud margins, then the deeper grey for the areas of heavier cloud. The result was mostly soft-edged, but I retained a few hard edges so the sky did not become too bland. I used a pale raw sienna wash for the water, then some of the warm wash wet-in-wet for soft shading from the left and just a little from the right. I put in the far bank with a warm grey wash of French ultramarine and light red, lightening the tone beneath the palest sky area, and strengthening the cloud reflection on the left with a broken, horizontal wash of the same colour.

The boats, landing stage and estuary banks in the foreground had to be deep-toned so the sky and the water would seem to shine by contrast. They would have looked flat and featureless painted entirely in silhouette, so I made sure the light caught the top of the gunwales and piles of netting, and used various mixes of French ultramarine, light red and burnt sienna for the tones and colours of the boats and landing stage. The shore was a broken wash of burnt sienna and French ultramarine, deepened to put in the wet mud and shingle bordering the water. The reflections were a deep, greenish grey and I added these in with a strong mixture of Payne's gray and raw sienna.

Water

Water is a complex subject, but one to which particular attention must be paid if your paintings of estuaries and coastal scenes are to succeed. Its challenge varies enormously with the effects of light, wind and tide. I believe the best approach is to study its varying moods between the two extremes of a dead calm and a stormy sea, and work out how best to capture these in a painterly way. A word of caution: water can present a highly complicated image with masses of detail – think of the complex patterns of reflections in a wind-ruffled surface – and it is all too easy to sacrifice freshness and immediacy in the search for accuracy. Look for techniques which suggest detail boldly and freely, while at the same time retaining the vital quality of movement.

 Reflections in still water on a windless day are a mirror image of the scene above, which may not be ideal from the viewpoint of the painter. A gentle breeze on the surface of the water may break the reflections into a mass of tiny shapes of varying tone and colour. If painted literally, this would involve excessive detail and loss of freshness. If the scene is viewed through half-closed eyes, however, the detail blurs into areas of differing tones and colours, which can be captured effectively using the wet-in-wet technique. Sometimes weather conditions make the reflections appear soft-edged, which naturally makes the job of capturing them far easier.

Hard-edged reflections

In some wind conditions the surface ripples will be larger – large enough, in fact, for them to be painted as they are. The reflections will be hard-edged and will be painted with indented edges to suggest the rippling surface of the water. It is vital to remember the rules of perspective here, and to make sure that the ripples decrease in size as they recede.

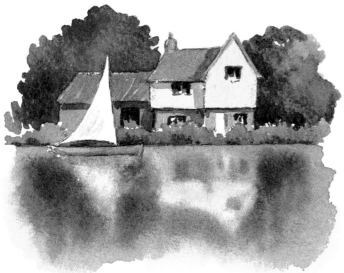

Soft-edged reflections

The wet-in-wet technique has many uses in watercolour painting, and it may be used effectively to depict soft-edged reflections in water. In the example left, a pale wash was applied over the area of the water surface, then smaller, darker washes, similar in tone and colour to the scene above, were applied with a series of vertical brush strokes.

Wind on water

When a strong, local breeze blows across the surface of water, it causes steep-sided ripples that reflect the sky above rather than the scene beyond. Local breezes like this may blow through gaps in surrounding hills or at an exposed bend in a river.

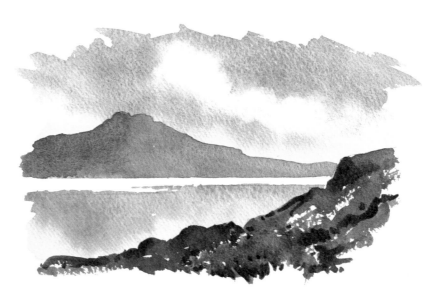

Sky reflections

When a patch of pale, disturbed water is seen at a distance, as in the example right, it is much foreshortened and will appear as a line of pale tone. Its inclusion in a painting not only helps the water to 'lie flat', but can serve the useful purpose of separating the distant scene from its reflection.

Moving water

As estuaries widen out to meet the sea, there is more space for the wind to affect the surface and the ripples become small waves. In the open sea, the wind has a greater impact, and in stormy conditions waves can reach impressive proportions.

Moving water is more difficult to paint than smooth, for nothing stays still and the wave pattern is constantly changing. When working from nature, it is important to memorise the subject at a point in time and paint that memory. This is not quite as difficult as it sounds, as wave formations frequently repeat themselves, and a similar image will recur every few seconds.

There are a number of effects to which particular attention should be paid. Observe carefully how waves become steeper and curve over just before breaking, and how the light may shine through them at this point. Notice too how the lines and streaks of white foam follow the surface contours of the water and slope upwards as the wave gathers itself before breaking.

Tip

Masking fluid can be useful for preserving the pattern of the foam on waves, but it should be used with discretion or the end result will be too obvious and artificial.

Breaking waves

It is usually better to concentrate on one, or at the most two, waves and indicate the more distant wave forms more economically, perhaps by leaving a few horizontal chips of white paper, as shown in this example.

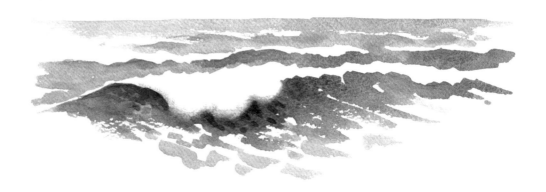

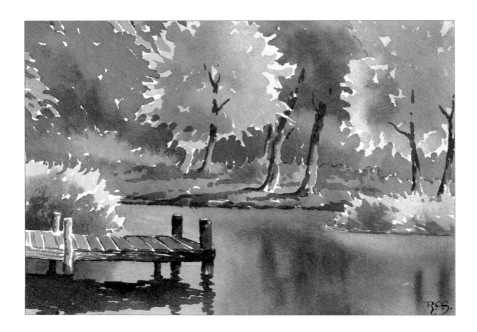

Landing Stage

The smooth, wet-in-wet treatment of the water makes an effective contrast with the complex pattern of the background trees. Note how the dark section of the landing stage stands out boldly against the pale water.

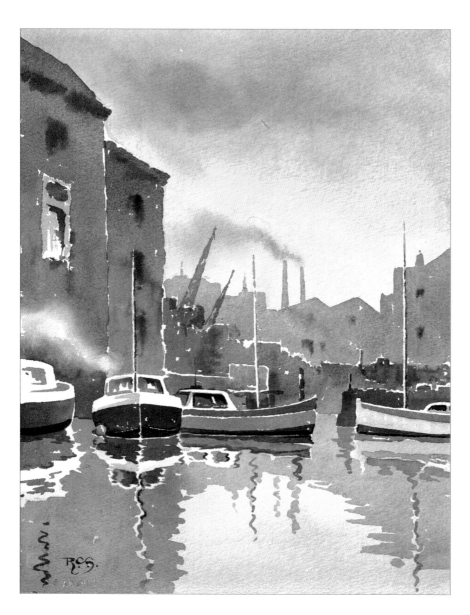

Industrial Backwater

The smooth treatment of the sky and the warm grey washes of the buildings suggest a livelier treatment of the water. The hard-edged reflections, indented to indicate the rippling surface of the water, provide the necessary contrast.

For more examples of industrial landscapes, see pages 42-43

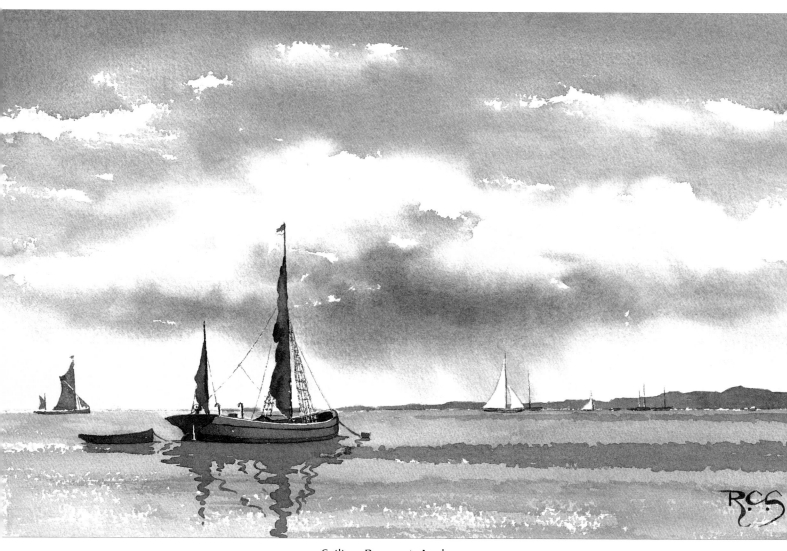

Sailing Barge at Anchor

The foreground boat is balanced by the distant landform and the cloud shadow on the sea. The calm surface of the estuary permits a hard-edged reflection, the indented edge of which suggests the ripples of the surface.

Boats

Many different kinds of craft can be seen in estuaries and coastal waters. My preference is for working boats rather than pleasure craft, and for white sails rather than the increasingly popular coloured variety – with the honourable exception of the traditional red sails of seagoing barges.

Viewed in profile, the shapes of hulls present few problems but it is another matter when they are seen at an angle, due to the fact that their subtle lines curve in two planes. As with most drawing problems, the answer lies in careful observation.

Coastal fishing boat

Fishing boats, with their cabins, superstructures and cluttered decks, make interesting subjects. For this study, I dispensed with much of the rigging and other details in the interests of simplicity and aimed for an overall impression rather than precision.

Open boats

As you can see, the nearer gunwales have pronounced curves while the further appear almost as straight lines. We know they are really similar shapes, but our angle of sight virtually cancels out the appearance of curves in the more distant.

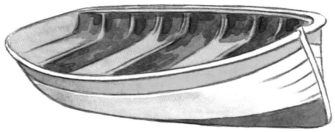

Racing yachts

The white sails make a strong statement against the stormy sky. The boats are sailing into the picture rather than out of it, an arrangement which ensures that the viewer's eye is kept on the painting. Two other points are also worth noting, both in the interests of good composition: the horizon is well down, rather than exactly halfway down the paper; and the nearer boat is well to the left of centre.

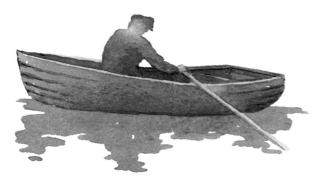

Rowing boat

Posture is more important than detail when painting the figure.

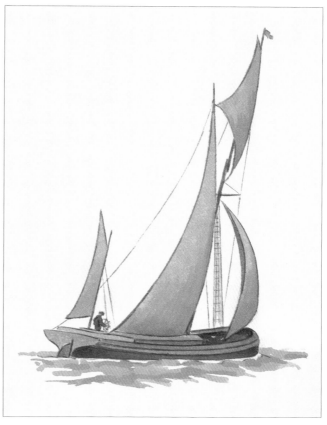

Sailing dinghy

These make more modest, but in their own way equally attractive subjects, and merit careful study.

Sailing barge

Spritsailed sailing barges make splendid subjects for the marine painter. With their shallow draught and retractable keels they can sail far up river estuaries and were widely used as bulk carriers. Sadly, they are much less numerous than they used to be, but some have been preserved by enthusiasts.

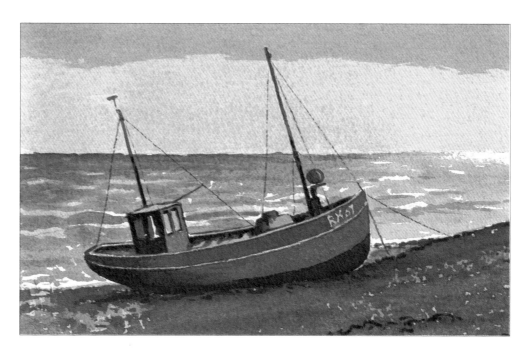

Fishing Boat, Dungeness

The two masts of this fishing boat drawn up on the shingle tie the elements of land, sea and sky together.

Estuaries

The word estuary conjures up a broad expanse of water, perhaps dotted with boats of varying shapes and sizes. From the artist's point of view, the fringing landforms are equally important and the wide variety of subject matter they contain must be considered. Where the surrounding land is low-lying and flat, it may consist of moody marshland or saltings with reeds in abundance, but few trees. If it is drained and free from salt, it may well be rich farmland, with hedgerows and trees. As previously seen, the local geology will play a decisive part in shaping the scenery: for example, chalk may give rise to rolling downland while harder rocks produce rugged and often mountainous terrains.

There may well be human settlements of various sizes on the estuary banks, their size depending on the economic development of the hinterland. These may range from small fishing villages, residential areas and holiday resorts to busy ports and large-scale industry. On the following pages, I shall explore the ways in which the feeling and atmosphere of such diverse scenery can be captured in fresh, transparent watercolour washes.

WOODS AND TREES

I will begin with trees and bushes, and consider how their complex forms may be simplified to make them amenable to bold watercolour techniques.

If you attempt to paint the bewildering complexity of leaves and twigs literally, you can become bogged down in detail and produce over-complicated, tired work. To avoid this, the subject must be simplified greatly. The best approach is to view your subject through half-closed eyes, so that detail is lost and you are left with areas of different tones and colours: it is these that you should seek to capture in your painting. Another important decision is how best to convey the broken outline of the tree, without resorting to countless tiny dabs of paint. My method is to apply the wash using the side of the brush rather than the tip, as with the broken wash technique. Using a rough paper helps to produce the desired broken outlines, with gaps here and there through which sections of trunks and branches may be glimpsed.

Practise a few boldly executed trees, and you will be surprised how quickly and economically you will be able to capture the effect you want. Concentrate on achieving a broken outline, but make sure you keep the overall shape of the tree constantly in mind. If you are painting a group of trees, look for local variations in colour rather than settling for just one shade of green. The colour variations are there, though they may need a little emphasis to add interest to your work.

Simplified tree

I prepared two washes: raw sienna with a little Winsor blue for the sunlit foliage, and raw and burnt sienna with some Payne's gray for the shadows. I applied the paler wash first using a No.10 round brush, then dropped in the deeper wash, wet-in-wet, for the areas of shadow, and a few branches in the 'sky holes'.

Middle distance

In the middle distance the local colours of the trees will be visible as well as the blues and greys of aerial perspective, and may be dropped into the blue-grey wash, wet-in-wet, as in this sketch.

Distant hills

Distant groups of trees can often be captured effectively with a single blue-grey wash. I applied a pale wash of French ultramarine and a little light red for a distant hill, adding a little raw sienna towards the bottom to bring it nearer. I let it dry, then deepened the original wash and added the woods and hedgerows. Note how the contours of the hills influence the lines of the hedges.

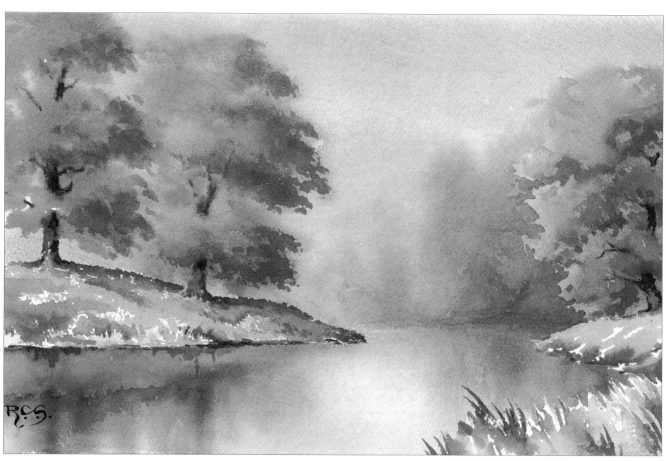

Riverside Trees

This example of foliage in misty conditions shows the use of aerial perspective.

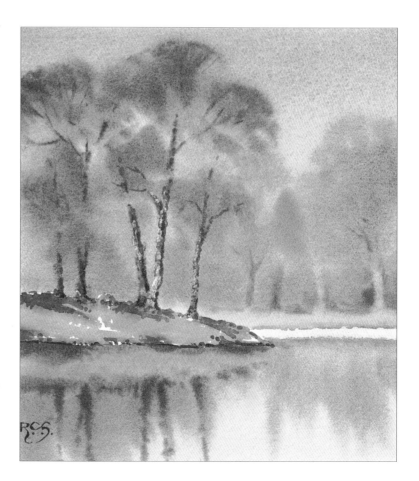

Autumn Trees

Note how the choice of colours can suggest the season.

MOUNTAINS

When rivers make their way to the sea through mountainous terrain, the scenery is often spectacular and dramatic. Where the land has sunk, the sea has invaded the lower courses to form *rias*, or drowned valleys. There are many examples in the West Country, and they make appealing subjects for the perceptive painter.

The shape of mountains depends on the type of underlying rock. In general terms, the hard, old rocks give rise to steep and rugged forms, while the softer, more easily weathered variety produce smoother outlines. Rugged scenery can be further dramatised if painted against a stormy background of nimbus cloud, and such subjects challenge watercolourists to demonstrate that their medium need not be a wishy-washy one. The sketch (below) of an estuary in mountainous terrain illustrates this type of treatment. A quick study of this sort can be a useful preliminary to a more ambitious painting.

Tonal sketch

Tone is an important thing to consider when composing estuary scenes, and you may find that a preliminary tonal sketch will sort out any problems. A deep-toned foreground will make the water appear to shine by contrast and by modifying the scene, you may well give your painting extra life and interest.

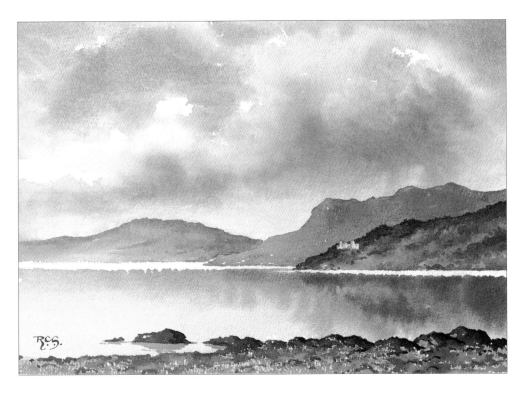

Highland Vista

My colour palette and methods were similar to those used for the painting opposite, except for the treatment of the water where the reflections were soft-edged. I prepared several washes approximating to the colours of the scene above, and then applied a pale, liquid wash to the whole area of water, except for the distant band of pale, disturbed water which I left untouched. I dropped in my prepared washes wet-in-wet with bold, vertical brush strokes. Finally, the foreground darks were placed against the pale areas of the estuary waters, which helped, by contrast, to make them shine.

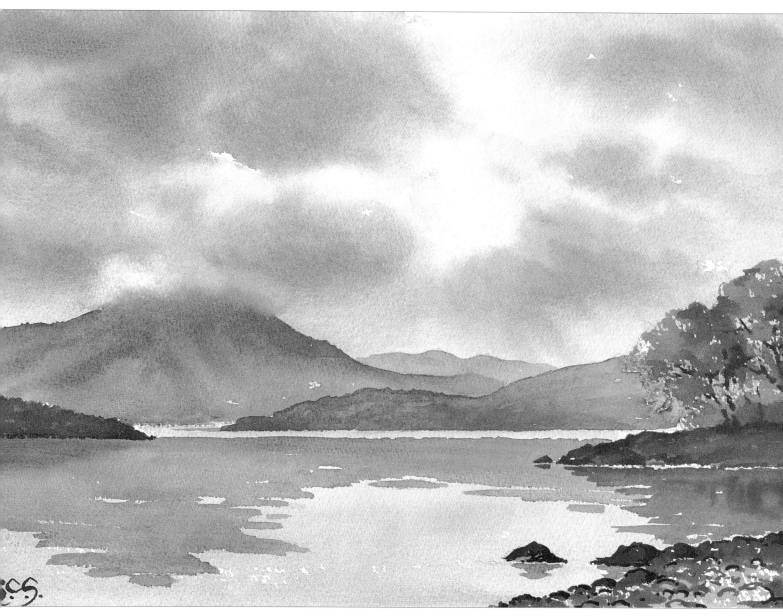

In Wester Ross

I painted this one cloudy day in autumn and began, as usual, with the sky. The cumulo-nimbus clouds made a lively pattern: I used full washes of French ultramarine and light red for the cloud shadows, and of palest raw sienna for the sunlit areas, allowing them to blend.

I used a stronger version of the same mix for the distant mountains, dropping in, wet-in-wet, hints of their local colours. The autumnal trees on the right were mainly of burnt sienna, with added shadows and sections of branch in an even deeper blend of French ultramarine and light red. I used the 'side of brush' technique to capture the broken outlines of their foliage. I made the most of a line of pale, disturbed water which enabled me to separate the mountains from their reflections in the smooth water. These reflections were pale washes of the colours used for the mountains and trees, and I indicated the rippling surface of the estuary by indenting the edges of these washes. The foreground was a broken wash of burnt sienna, with shadows and some final detail added with a small brush in a deep mixture of burnt sienna and French ultramarine.

FARMLAND

In fertile areas, the land fringing estuaries may be intensively cultivated, with farmland stretching down to the water. According to the season, the fields may be green with meadow grass or growing cereals; warm yellow with ripening corn, or the rich brown of ploughed earth. There may be orchards, fields of soft fruit or vegetables, woods, copses and hedgerows.

Field divisions

Pale, smooth washes may be used for distant fields, with local colours modified by the blues and greys of aerial perspective. For foreground fields, stronger, warmer colours are needed, perhaps applied as broken washes to suggest detail and texture. Make sure field boundaries are in harmony with the lie of the land and accurately reflect its gentle contours.

Distant farm buildings

These are an important part of the agricultural scene, and often have a distinct regional character which should be reflected in your painting. The limestones of the Cotswolds and the clay tiles and bricks of the Weald are two examples of local building materials which influence strongly this regional character.

The direction of light

This is an important consideration. Light falling directly on a group of buildings can make them look flat and two-dimensional, but a lateral light may produce interesting shadows which help to give the group solidity and substance. If you compare the two extremes in the sketch below, you will see what I mean.

Direct light

Lateral light

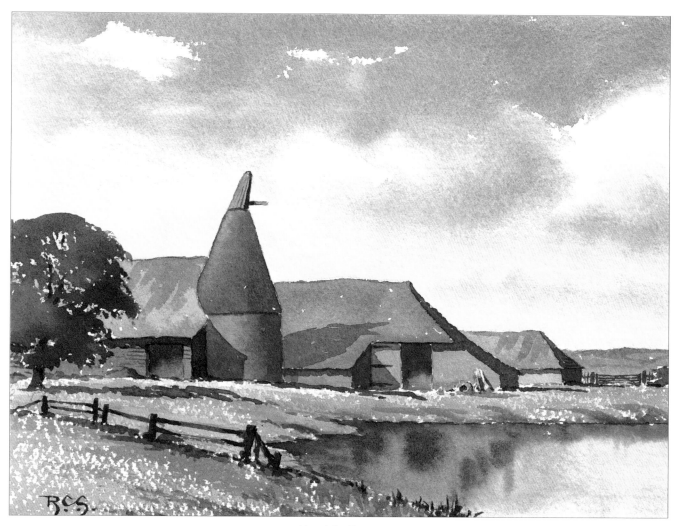

Kentish Farm

Foreground buildings require a more complete treatment. Texture or weathering may be suggested with broken washes or dry brush work. For slate or tile roofs, brush strokes should follow the roof slope, which helps to reinforce its underlying gradient. Artistic licence may be justified to achieve a more pleasing composition, and you may, for example, wish to place dark trees behind a sunlit building for tonal contrast.

INDUSTRIAL LANDSCAPE

Many painters seek their inspiration exclusively from the countryside and the beauties of nature, and it is perfectly natural that those who live in towns should look for recreation and relaxation away from concrete, bricks and mortar. The rural scene provides us with a lavish supply of unspoilt beauty, but you should not close your eyes to the fascinating subject matter which can be found in the most unexpected places, particularly in towns and cities.

A successful painting presents a pleasing and interesting pattern of tones and colours, and using that criterion, what it represents becomes irrelevant. Artists should strive to convey feeling and atmosphere, qualities which are in abundance in many urban scenes. An industrial skyline against a misty evening sky, or reflected in wet streets, are two examples that spring to mind.

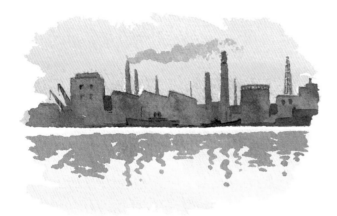

This sketch shows how distant factory buildings and chimney stacks, reflected in the waters of an estuary, may be treated in a fast, impressionistic way.

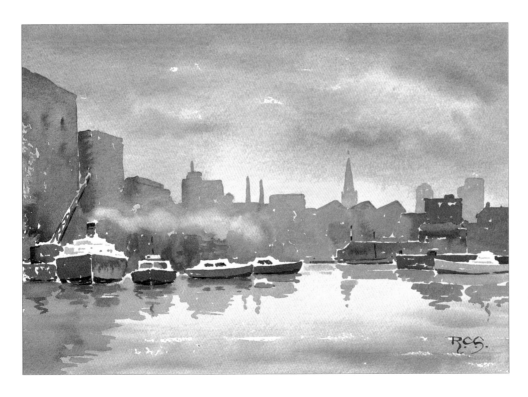

Dockside Warehouses

The industrial buildings are loosely indicated by a flat wash with a little darker detail added, wet on dry. This wash is broken by the soft-edged smoke from the moored boat on the left.

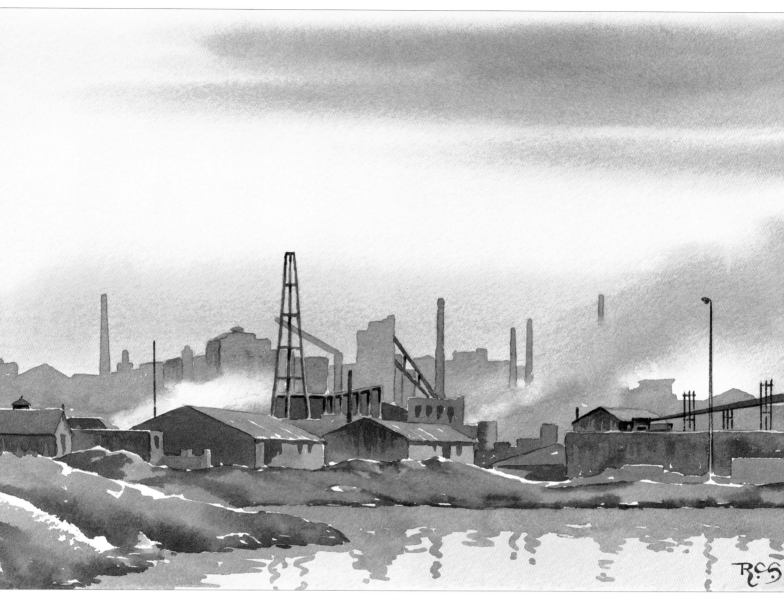

Last Days of Ravenscraig

This painting shows the giant Scottish steelworks at a time when closure was imminent. The stark pattern of industrial plant against a warm evening sky had a strange, haunting beauty, and I aimed to capture something of its melancholy atmosphere.

I began with a quick tonal study, then sketched in the principal lines of my composition on 640gsm (300lb) watercolour paper. For the warmth of the sky, I used a wash of pale raw sienna and light red, with added French ultramarine and alizarin crimson for the soft haze in the lower sky. The stratus clouds were a mix of French ultramarine and light red, applied with a large brush, wet-in-wet, to preserve their soft edges. While the sky area was still moist I used a similar wash for the smoke still rising from one of the furnaces.

The background buildings were a pale silhouette of warm grey, and for this I used various combinations of French ultramarine, light red and burnt sienna, allowing the colours to merge and blend. Stronger washes of the same colours, in varying proportions, served for the nearer shed and, in greater strength, for the poles, standards and gantries. I treated the foreground very roughly so that it would not compete for attention with the steelworks. I used a pale wash of raw sienna and light red for the water and, when it was dry, added the reflections with a light wash of French ultramarine and light red. The indented edges of these reflections suggest a gentle rippling of the surface water.

Marshes

When rivers wend their way to the sea through low-lying terrain, the areas bordering their estuaries may be marshy, perhaps criss-crossed by drainage ditches and punctuated by patches of reed. Reed beds can cause difficulties, and inexperienced painters often make the mistake of trying to put in each individual blade. It is usually better to look at reeds as a mass and paint them accordingly, with just a few vertical brush strokes and a spiky outline to give a suggestion of form, as in the example below.

The painting opposite shows the estuary of a small Norfolk river as it meanders through marshy terrain on its journey to the North Sea. Landmarks, such as the distant church tower, dominate the landscape. The few trees – like the one to the right in the painting – are small and windblown. Although the foreground was in shadow there was a lovely shine on the water, very similar in tone and colour to the areas of clear sky.

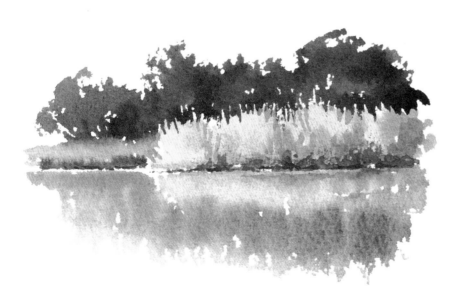

Reed beds

I used a pale wash of raw umber for the sunlit areas in this bold treatment of reeds, and a wash of French ultramarine and light red for the shadows. The dark hedge behind provided useful tonal contrast.

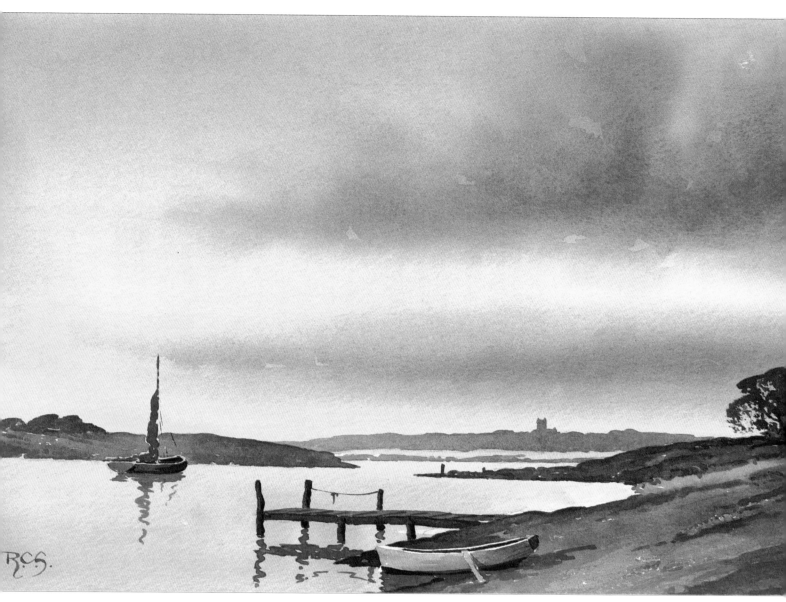

Blakeney Marsh

I began by preparing three washes for the sky: pale raw sienna for the warm area just above the horizon, raw sienna with a little Winsor blue for the upper sky, and a deeper wash of French ultramarine and light red for the grey clouds. I applied the first two as a pale, variegated wash, allowing them to blend smoothly together and, while the paper was still wet, added the deeper grey wash, wet-in-wet, for the clouds. When the sky was dry I strengthened the upper clouds, softening the wash in some areas but leaving a suggestion of hard edges in others. The water was another pale, variegated wash of raw sienna merging into a hint of Winsor blue towards the foreground. When everything was dry, I applied a wash of French ultramarine and light red for the distant scene, which included the church tower, diluting it a little towards the left, below the area of bright, clear sky. The foreshortened strip just below was in sunlight and for this I used pale raw sienna.

I wanted to capture the shine on the water, so I used much deeper tones for the surrounding land and the little landing stage to provide contrast. I used various proportions of French ultramarine and light red for the muddy river banks, and raw sienna and Payne's gray for the grass, weeds and foliage. The foreground rowing boat was actually brown, but I changed this to white, again to provide added tonal contrast. The reflections in the water had a greenish tinge for which a mixture of raw sienna and Payne's gray was just right. Finally, the moored sailing boat on the left, with its russet sails, helped to balance the composition.

Welsh Estuary

The watercolour medium enables you to capture the atmosphere and majesty of mountain landscapes with bold, fresh washes, and to suggest recession by accentuating the soft, blue-greys of the far hills.

This section of the Mordach Estuary in Wales made an ideal watercolour subject, with the warm colours of the mountains giving way to cool as they recede into the distance. Above, there was a pleasing pattern of billowing cumulus clouds, and the mountain crests stood out boldly against the pale warmth of the lower sky. The weather conditions were such that the water reflected the sky above rather than the mountains beyond, and so was very pale.

A horizontal, foreshortened stretch of sand broke the expanse of pale water and the remains of a breakwater made a dark accent in the foreground.

Preliminary sketch
Sketch out the main features of the composition using a 2B pencil.

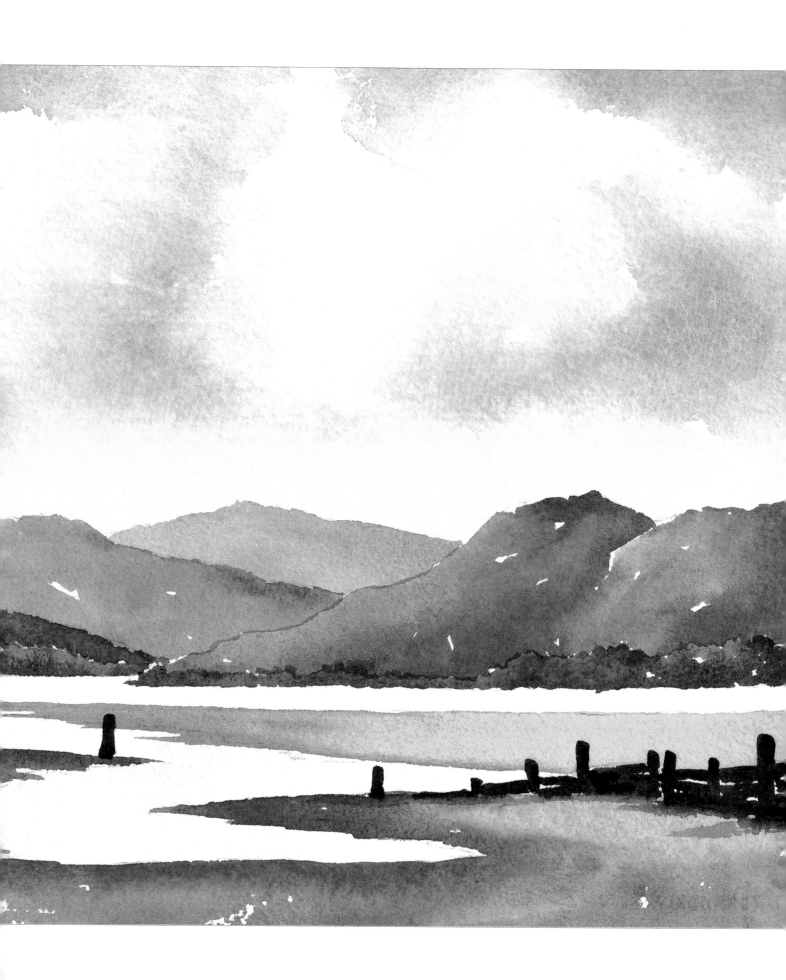

YOU WILL NEED

Drawing board
Watercolour paper: I used quarter
Imperial size Rough, but Not
would also be suitable
Watercolour paints: basic palette
only (see page 13)
Round brushes: Nos. 8 and 10
Flat brush: 25mm (1in)
2B pencil
Putty eraser

I began by mixing three washes for the sky:

1. *Raw sienna with a touch of light red (for sunlit areas of cloud)*
2. *French ultramarine with a touch of light red (for cloud shadows)*
3. *French ultramarine with a little Payne's gray (for the blue of the sky)*

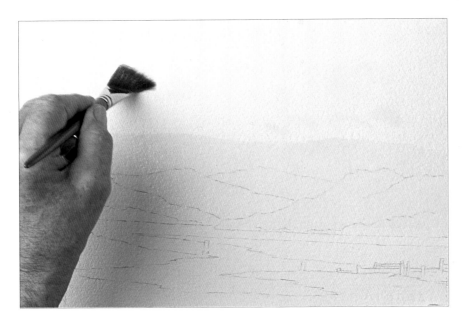

1 Using a 25mm (1in) flat brush, put in a wash of raw sienna with a touch of light red over the lower sky and, diluted, for the sunlit clouds.

2 Still using the flat brush, add the cloud shadows wet-in-wet using a mix of French ultramarine and light red.

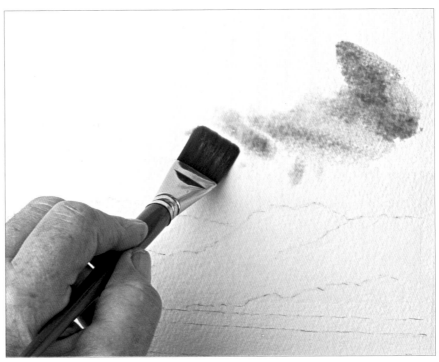

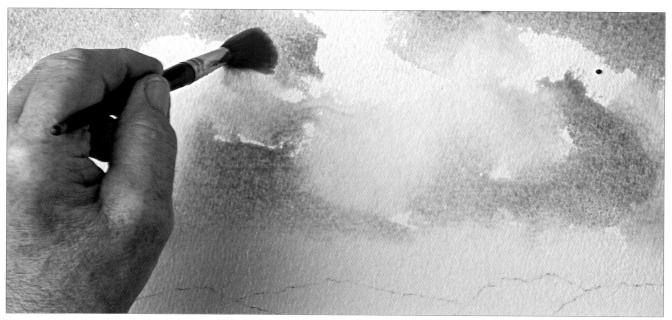

3 Add patches of blue sky, top left and top right, using the mix of French ultramarine and Payne's gray, and allow some blending with the clouds.

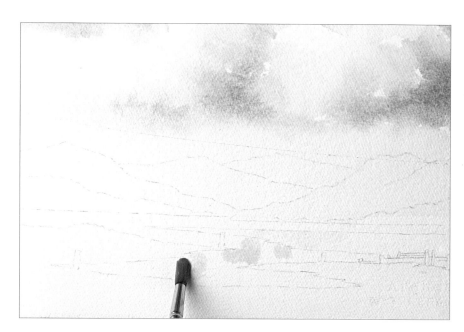

4 Change to the No.10 round brush and apply the pale raw sienna and light red wash to the area of water. When this is dry, apply a few vertical strokes of the pale cloud shadow wash.

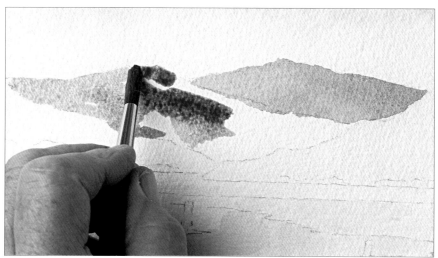

5 Put in a cool grey wash for the more distant mountain. Add the green slope using a mix of raw sienna and Winsor blue and, while it is still wet, put in shadow tones using a mixture of French ultramarine and a little light red.

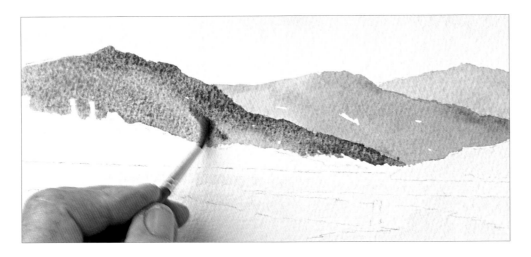

6 Change to the No. 8 brush and add the warmer colours of the nearer mountains using washes of raw and burnt sienna. Blend softly into the cool tones of the shadows.

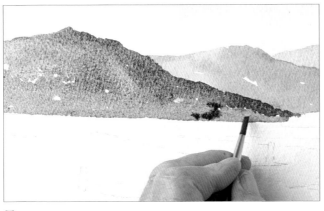

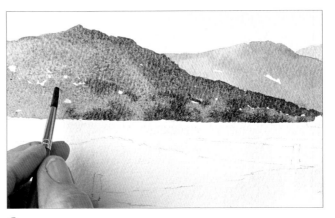

7 Working wet-in-wet, paint in the trees fringing the estuary using a mix of raw sienna with a little Winsor blue. Drop in shadows, again wet-in-wet, in strong Payne's gray.

8 Build up the shadow tones of the bank of trees.

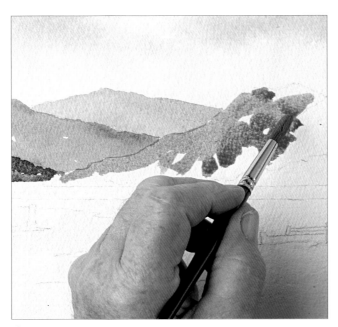

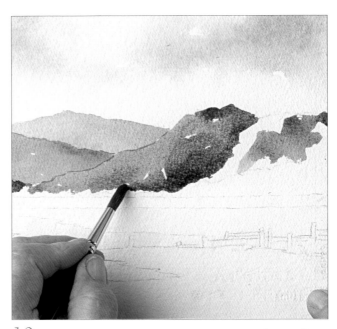

9 Apply a wash of raw and burnt sienna to the mountain on the right then, working wet-in-wet, drop in a wash of French ultramarine and light red for the shadows.

10 Add another patch of raw and burnt sienna then, still working wet-in-wet, drop in a darker wash made from French ultramarine with a little light red for the cooler shadows.

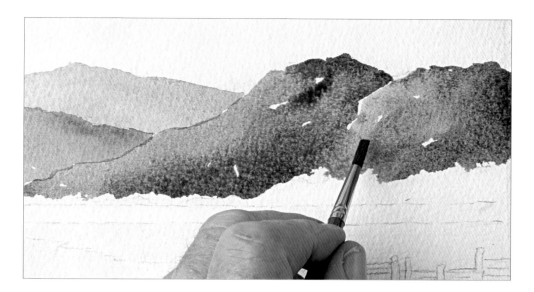

11 Move the paint gently with your brush to assist the blending of the warm and cool washes, leaving space for the line of trees.

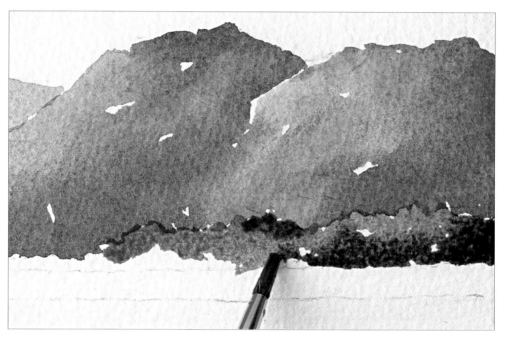

12 Paint in the line of trees using raw sienna with a little Winsor blue added. Working wet-in-wet, add the shadows with a deeper mix of Payne's gray and a touch of burnt sienna.

13 Carry these washes to the left to complete the line of trees.

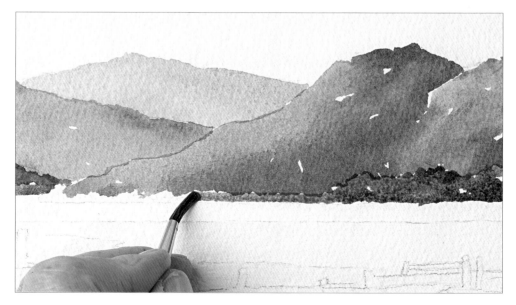

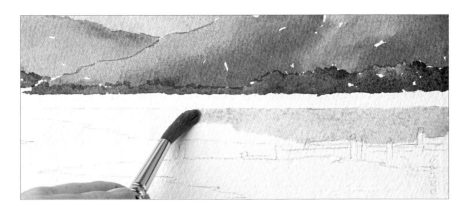

14 Now paint in the spit of sand using raw sienna.

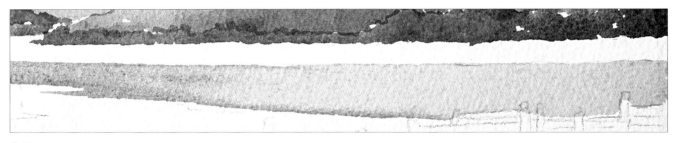

15 Working wet-in-wet, merge a pale grey wash made from French ultramarine and a touch of light red to add shadow to the sand spit towards the left.

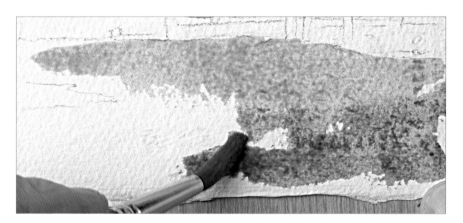

16 Start to paint in the sandy shoreline in the foreground using raw sienna, adding a little Winsor blue to paint in the green tones wet-in-wet.

17 Still working wet-in-wet, using various blends of burnt sienna, light red and French ultramarine, add some deeper tones for the areas adjoining the water.

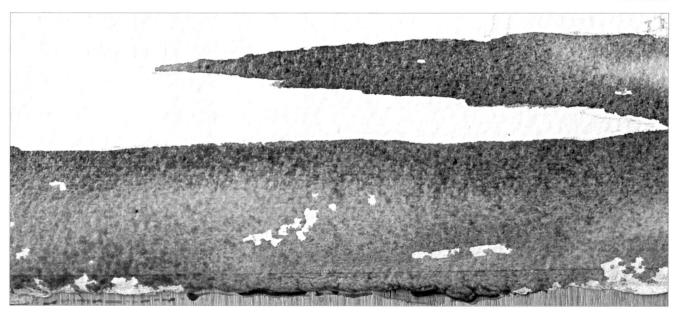

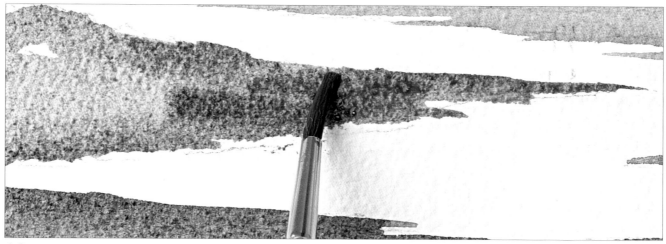

18 Paint in a sandy promontory using raw sienna, adding a deeper tone wet-in-wet using a mix of burnt sienna, light red and French ultramarine.

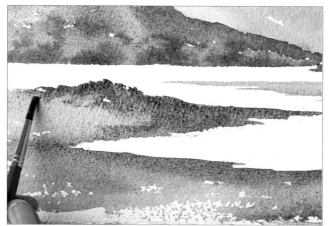

19 Add a little Payne's gray and raw sienna to represent weeds

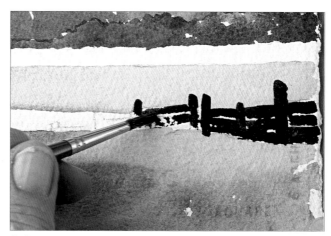

20 Put in the breakwater using a strong mixture of burnt sienna and Payne's gray.

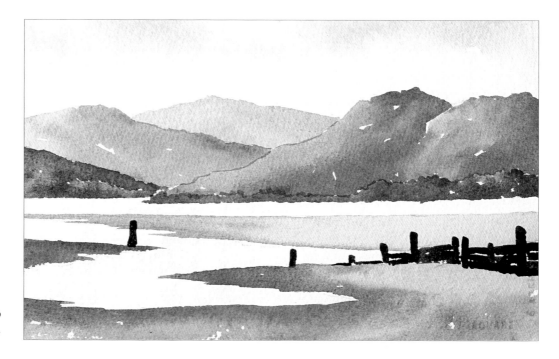

21 Add a few posts to complete the painting.

Devon Estuary

When the sky above your subject contains an attractive pattern of clouds, it makes good sense to give it plenty of space and so adopt a low horizon. This arrangement still enabled me to include the interesting reflections of the buildings, boats and trees.

Most of the weight of the composition was firmly on the left of the picture, so I ensured that the heaviest cloud formations were on the right to provide some balance, and, for good measure, included the two distant sailing boats. Some inexperienced painters, when they first learn about the rules of composition, jump to the conclusion that tonal weight must balance exactly on either side of the painting. This is not the case and smaller, paler objects can often provide adequate compositional balance.

The group of dark trees makes the cottages stand out boldly, and the shadows cast by the strong lateral light give them a solid and three-dimensional appearance.

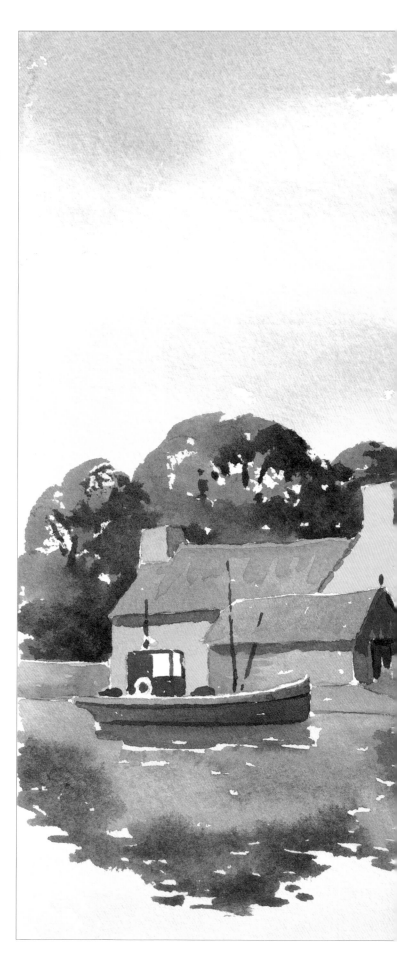

Preliminary sketch.

Sketch in the main features of the composition lightly using a 2B pencil.

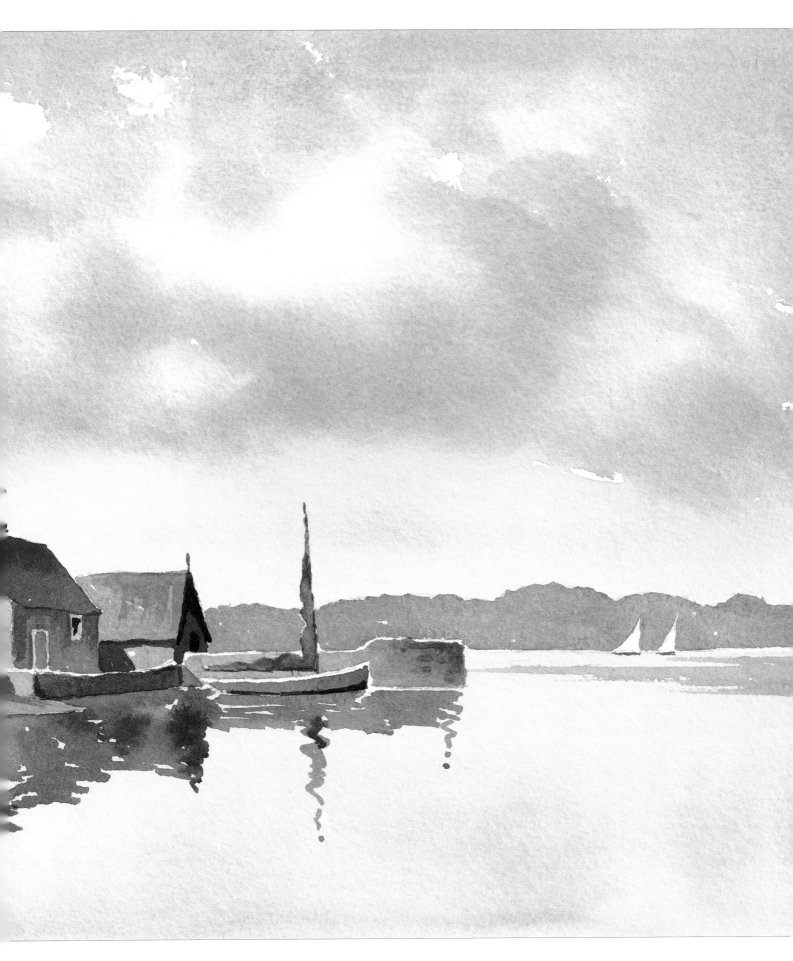

I began by mixing the three washes for the sky:

1. *Raw sienna with a touch of light red (for the warm, pale areas)*
2. *French ultramarine and light red (for the cloud shadows)*
3. *French ultramarine with a touch of Payne's gray (for the area of blue sky)*

1 Using a 25mm (1in) flat brush sweep a pale wash of raw sienna with a touch of light red over the lower sky area. Dilute this wash and paint in the areas of sunlit cloud. Working quickly before the wash dries, add the cloud shadows using a mix of French ultramarine and light red.

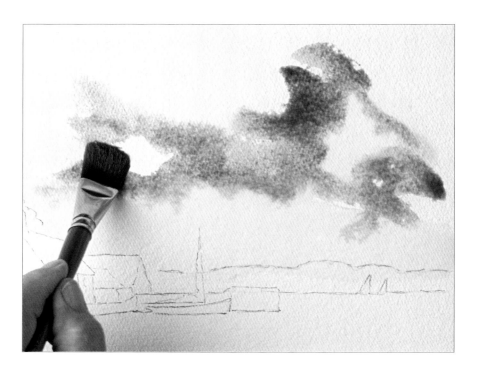

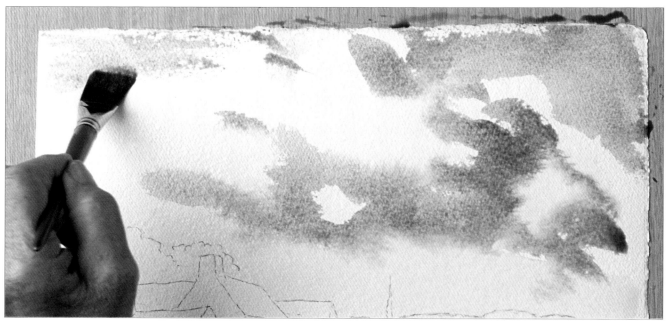

2 Put in some blue at the top of the sky using French ultramarine with a touch of Payne's gray.

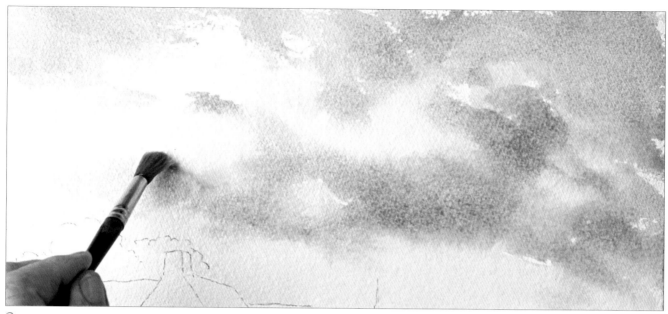

3 Change to the No.10 brush and, if necessary, add a little more cloud shadow while the sky area is still wet.

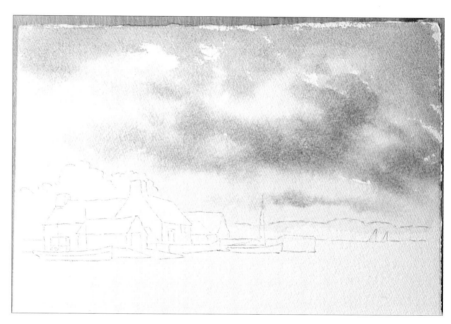

4 Let the sky area dry.

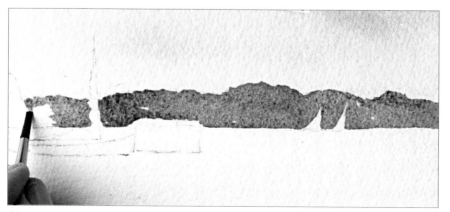

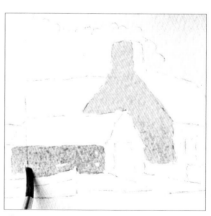

5 Change to the No.8 brush and paint in the distant line of trees at the edge of the water using a fairly strong wash of French ultramarine and a little light red. Paint very carefully round the mast of the boat in the central area of the picture, and the small triangular sails on the right.

6 Begin to paint in the sunlit walls of the cluster of buildings.

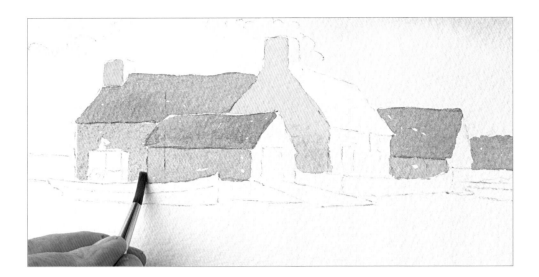

7 Continue to paint the lighter sunlit surfaces of the buildings, making the most of the variations in colour.

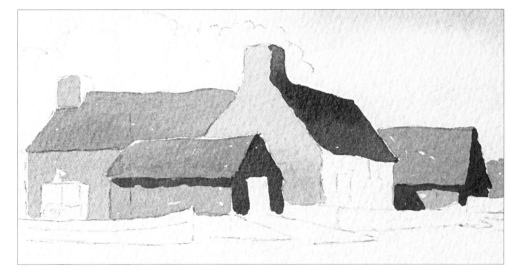

8 Start to paint the surfaces in shadow, using varying strong mixtures of French ultramarine and light red.

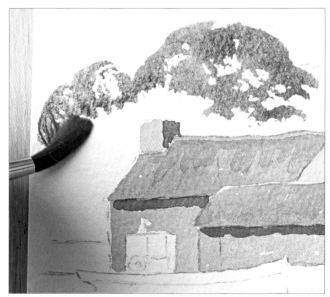

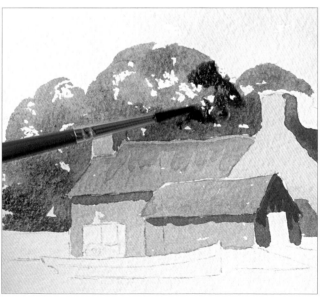

9 Begin to put in the shapes of the trees behind the buildings using a mix of raw sienna and Winsor blue. For a broken foliage effect do not overload the brush with paint and use the side rather than the tip of the brush.

10 Put in the rest of the tree, leaving small gaps in the foliage where appropriate. Drop in a strong mixture of Payne's gray and raw sienna wet-in-wet for the shadowed areas.

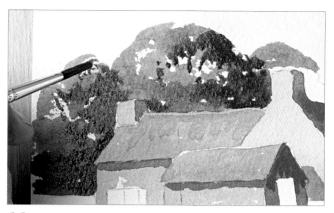

11 With the same deep wash, add a few details of branches to the trees.

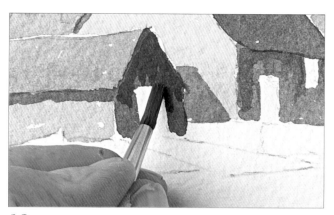

12 Add a little texturing with vertical strokes of deep French ultramarine mixed with a little light red.

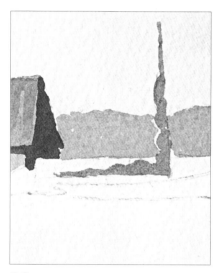

13 Paint the furled sail in light red, with ultramarine and light red shadows dropped in wet-in-wet.

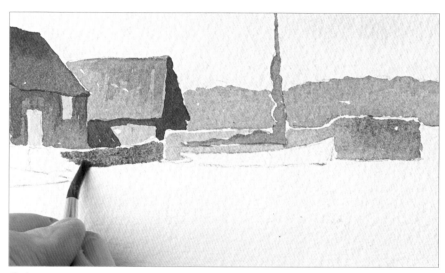

14 Using burnt sienna plus a little French ultramarine, paint the shadowed harbour wall.

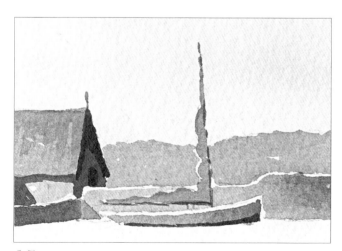

15 Use French ultramarine to put in the hull, deepening the tone towards the right.

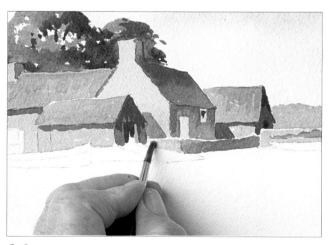

16 Put in the sunlit harbour wall with burnt sienna mixed with a little burnt umber. Drop in raw sienna with a little Winsor blue to suggest seaweed.

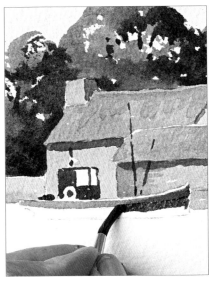

17 Paint the hull in Winsor blue with a little burnt umber below.

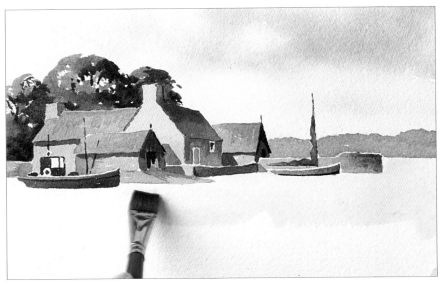

18 Using the flat brush, put in a pale wash of raw sienna with a touch of light red over the whole of the water area.

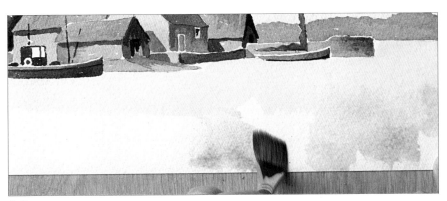

19 While the paper is still wet, drop in a pale mixture of French ultramarine and light red for the soft reflections of the clouds. Let your work dry.

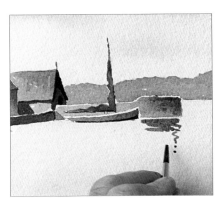

20 Using the No.8 brush, begin to put in the hard-edged reflections, with indented edges to suggest the rippling surface of the water.

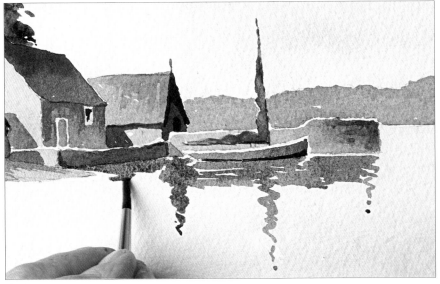

21 Using the same colours as for the objects reflected, put in the rest of the reflections, letting them run together in places.

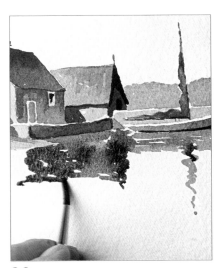

22 Working wet-in-wet, add deeper shadows where necessary.

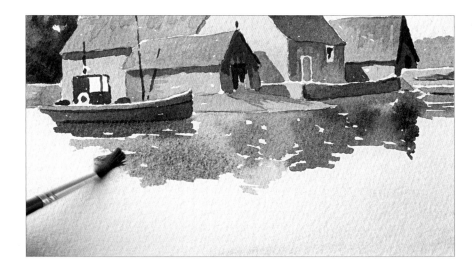

23 Continue to build up the reflections, leaving some white paper to represent chinks of light.

24 Paint in the nearer reflections, with indentations for the ripples.

25 Add a pale horizontal wash of French ultramarine with a touch of light red for a distant cloud shadow on the water. Paint in the hulls of the boats.

26 Add a few further details and finishing touches where necessary.

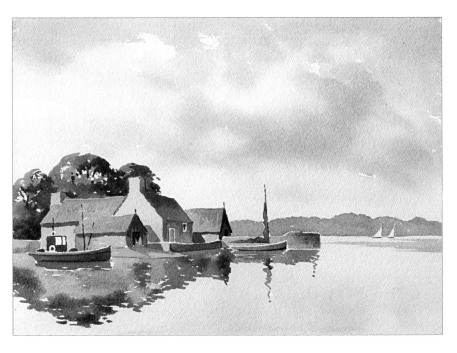

The finished painting

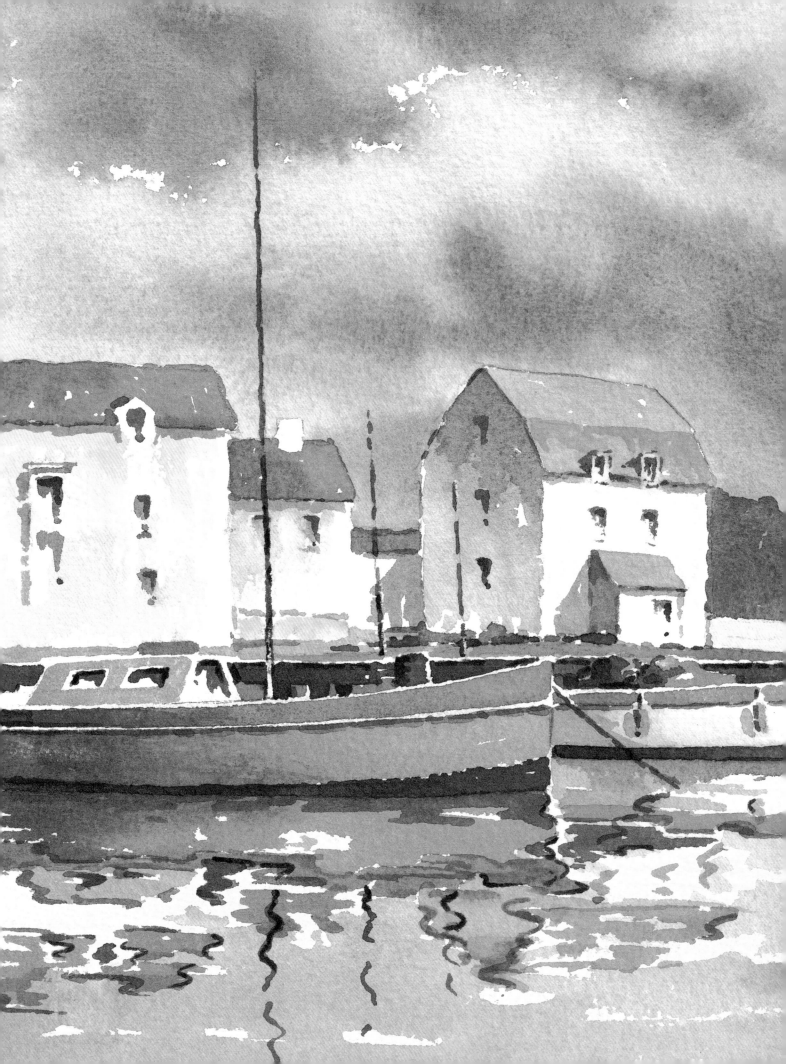

Coastal scenes

The underlying geology determines the type of coastline. Hard granites and the like give rise to broken, rocky formations, limestones to deeply indented and often spectacular effects, chalk to smoother and more vertical white cliffs – and so on. Land relief determines the height of the cliffs, which are naturally higher where the hills meet the sea. Coastlines are also strongly affected by social and industrial development. Great ports with extensive docking and warehousing facilities, seaside towns with piers and promenades, fishing villages with stone cottages and harbours are contrasting examples.

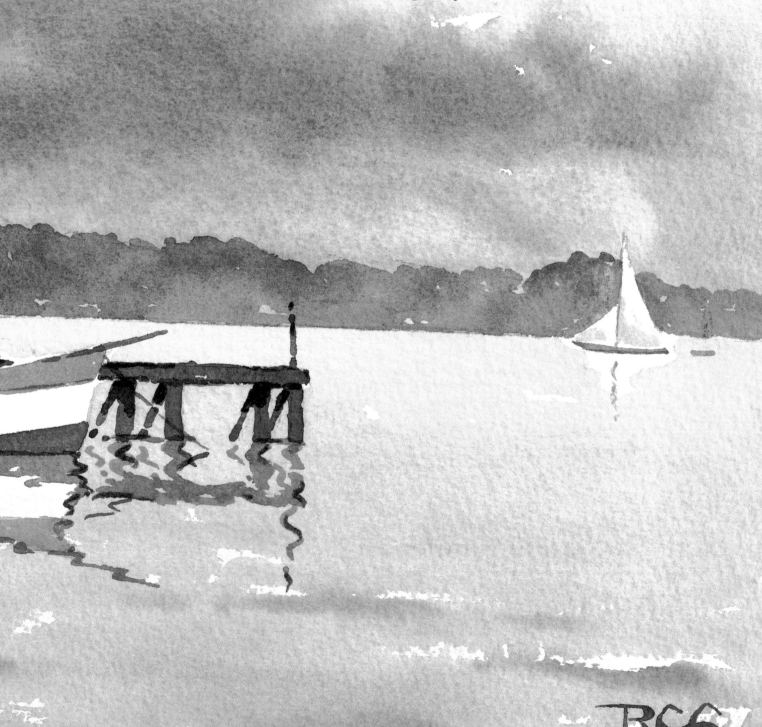

Beaches

The treatment of waves needs careful handling, with particular attention to perspective. Unless viewed head-on, the lines of incoming waves do not appear parallel to the horizon, but slope downwards as they approach the shore. The closer the waves, the steeper the slope. The lines of the waves will have a common vanishing point, so keep the rules of perspective constantly in mind, though the effects of coastal features and currents mean that rigid linear constructions cannot be used. The waves in the painting opposite obey these rules roughly, and their (very approximate) vanishing point would be on the horizon line, off the painting to the left.

The placement of headlands in relation to their height requires more consideration than it sometimes receives. In beginners' paintings, sometimes impossibly lofty landforms are placed right on the horizon. This raises the question: just how distant is the horizon? Some knowledge of this is needed to judge the size of distant features with accuracy. The answer depends on the height of the viewer above sea level. The time-honoured formula states that the distance to the horizon in miles is the square root, in feet, of the viewer's eye above sea level. If you are of average height, and are standing at the water's edge, the horizon will be about 4–4.8km (2½–3 miles) away. If you are on a cliff and your eyes are about 15.25m (50 feet) above the sea, the horizon will be just over 11.2km (7 miles) distant.

Coastal features may vary widely depending on the nature of the local rock, and when the tide is out there may be seaweed-encrusted rocks or rock pools. Some beaches are sandy, some shingly, and others a mixture of sand and pebbles. The colour of sand can vary greatly, from the near-white of coral strands to deep greys, sometimes almost black, in some volcanic areas. Wet sand bordering the sea will generally be darker than powdery dry sand, and if it is very wet it may even reflect something of the scene above. Lines of seaweed and other detritus often mark the extent of previous tides, and these are worth including as they help to describe the contours of the foreshore. Sand can be painted with pale, horizontal strokes of a large brush, perhaps with texture and tone added wet-in-wet or wet on dry.

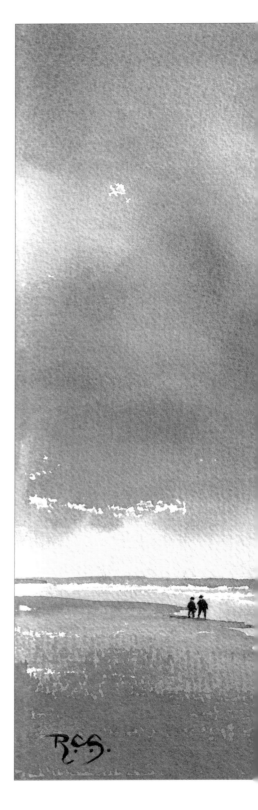

Shingle

This is best captured using broken washes with added calligraphic deeper tones to suggest some detail.

Wet sand

Wet sand is deeper in tone than dry.

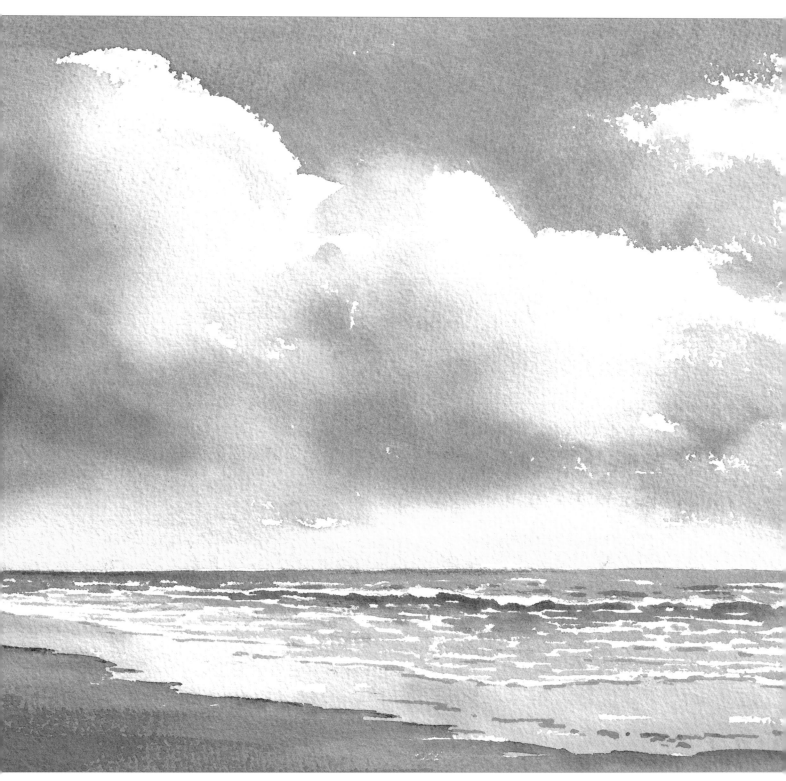

The Cold North Sea

The human figure may sometimes be used to establish scale. Here, the two tiny figures contrast dramatically with the huge expanse of sea, sand and sky and so help to create a telling impression of space.

ROCKY SHORELINE

The outline of the coast is shaped by the sea's ceaseless battle with the land. Where the underlying rock is soft this outline tends to be smooth, but where the rock is hard and resistant, the result is a rugged and deeply-indented shoreline. The form of rocky coastal features varies with the type of underlying rock, and it is important to observe their individual shapes carefully.

The three main categories of hard rock are sedimentary, igneous and metamorphic. Sedimentary rocks were originally laid down in layers, and became hardened over millions of years. The fissures and cracks caused by weathering and erosion tend to be parallel, and this gives the worn rock its characteristic shape. Earth movements over the years mean that these parallels may no longer be horizontal. Igneous rocks were formed by intense heat deep within the Earth's crust and weather to more random shapes. Metamorphic rock was changed by geological forces and falls roughly between the first two.

There is much to consider in painting rock formations: form, colour and texture must be observed carefully to do them justice. The effects of light and shade can enhance the appearance of rocks and emphasise their rugged form. It is often worth waiting until the sun is in the best position to produce the most interesting lights and shades.

The colours of rocks vary just as much as their characteristic shapes, from the white or honey-colour of limestone to the deep greys of some slates, and this should be reflected in your paintings. These colours will be modified by weathering, by moss and algae and, where they come into contact with salt water, with seaweeds of various kinds. Rugged coastlines are often fringed with white foaming water, and this makes the rock look darker by contrast.

The shape of the rocky coastline will naturally affect the pattern of the waves. Promontories jutting out into the sea will break the even lines of waves as they approach the shore. Not only will they cause bursts of spray where they challenge the approaching waves, but they will modify their direction and line as well. In the painting opposite, *Wave Burst*, the wave pattern is broken and a mass of white spray is thrown into the air. Notice how dark the rock seems against the white spray and foam. You may also notice the roughly-parallel seams and fissures in the rock, which suggest that it is a much-weathered, hard old sedimentary.

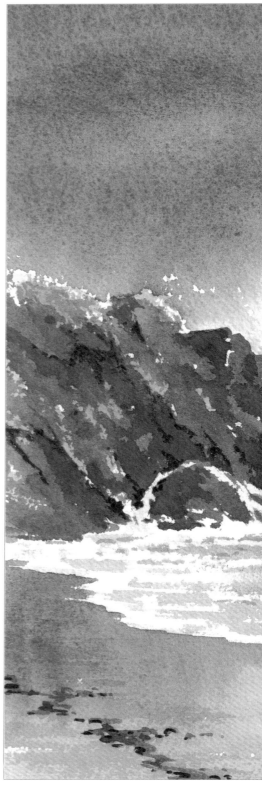

Foaming water, dark rocks

Waves and wave formations need particular study. Their constant movement can cause problems, and the answer is to freeze a particular moment in the mind's eye. Wave patterns recur constantly, so you can refresh your memory if necessary.

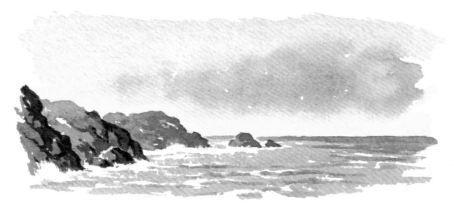

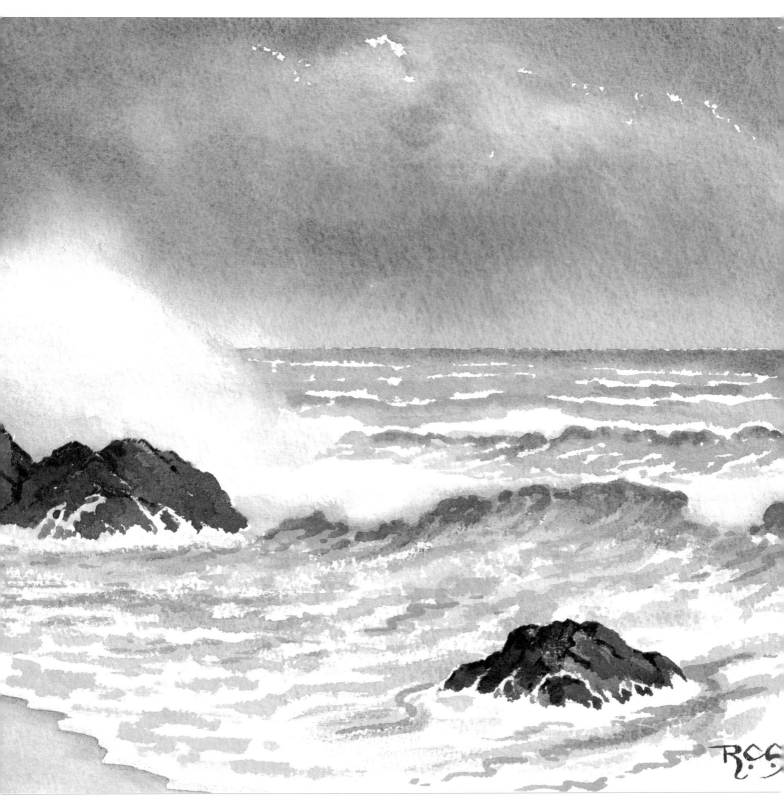

Wave Burst

It is usually better to concentrate on one, or at most two waves, and indicate the more distant wave forms economically, perhaps by leaving a few horizontal chips of white paper, as in this painting.

Cliffs

The form and shape of the coastline, especially cliffs, is fundamentally affected by the nature of the underlying rock. Hard, old rocks like granite and slate are most resistant to the constant erosion of the sea, and areas of the greatest strength form promontories, while those containing faults and fissures are more vulnerable and eventually become sea inlets. Small islands of the hardest rock may be cut off from the land, and these add to the irregular coastal pattern. Limestones tend to dissolve in water and as a result often form deeply indented and sometimes spectacular cliffs. Chalk cliffs are different again, and are usually steep and smooth, while any isolated formations are, in geological terms, short-lived. Soft sandstones and clays are more vulnerable still to erosion and some East Anglian cliffs suffer severely from the effects of strong tides and coastal currents, and within living memory, whole villages have disappeared beneath the waves.

While some understanding of geology is helpful, more important is an ability to observe the scene, simplify it, and translate it mentally into terms the watercolour medium can handle. This may sound like a fairly vague process, so it may help if I describe how I set about trying to capture the essence of the subject of the painting *Seven Sisters* (opposite).

After some preliminary reconnaissance to find what I considered to be the most effective vantage point, I made a quick sketch, with the chalk cliffs on the left balanced by the building and trees on the right. I changed the direction of the track to carry the eye towards my centre of interest, the majestic white cliffs. I decided to deepen the tone of the grey clouds behind them to emphasise the brilliance of the sunlit chalk face, and this also helped the soft green of the downland turf to register.

Chalk cliffs

The height of cliffs naturally depends on the contours of the land as it approaches the sea. Where the South Downs of England meet the sea the result is lofty, almost vertical cliffs.

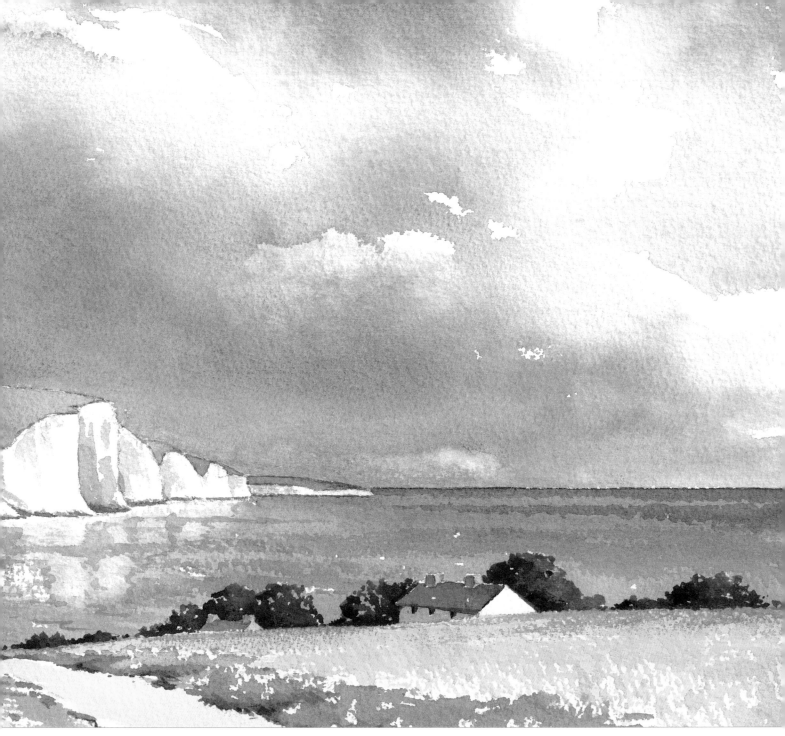

Seven Sisters

I began by preparing two washes: Winsor blue for the small patches of clear sky, and French ultramarine and light red for the grey clouds. I dampened the areas of sunlit cloud with plain water and applied these prepared washes in quick succession, allowing some blending to occur but preserving some hard-edged highlights. While the sky was still moist, I added a hint of alizarin crimson to the grey just above the horizon. I left the white paper untouched to represent the white of the chalk cliffs, with vertical brush strokes of pale French ultramarine and light red for the shadows.

The downland grass was pale raw sienna and Winsor blue, merging into French ultramarine and light red for the greyish cloud shadows. The sea was mainly Winsor blue with touches of raw sienna, with the same pale grey for the reflections of the cliff shadows. When the sea area was quite dry, I used a slightly deeper version of the grey wash for the horizontal cloud shadows, which helped the sea to 'lie flat'. I used a pale, warm blend of raw sienna with a touch of light red to bring the foreground field forward, applying it with a broken wash technique to suggest its texture. I deepened the tone of the line of trees to create tonal contrast and to separate the foreground from the scene beyond. The white gable of the foreground cottage helped to link both parts of the painting.

Harbours

Most painters prefer subjects that show the effect of time and weathering to those in pristine condition: a weather-stained stone wall has far greater appeal than a freshly-painted wall. One of the attractions of harbours and boat yards is the mellow, weathered material with which they are built.

Harbours come in all shapes and sizes, and imaginative artists will gladly spend time seeking out the fascinating subject matter to be found in all of them. They will look for pleasing compositions, for tonal and colour contrasts in the jumble of harbour-side buildings, for patterns made by groups of moored boats, for reflections in calm waters, and much more. They will be selective in the amount of detail they retain, realising that much must be sacrificed in the interests of simplicity but that some must be included in order to capture the feel and atmosphere of the subject. When have you ever seen a tidy boat yard, or an uncluttered harbour wall in a fishing village?

I believe the most useful approach to this section is to show you a few of my harbour-side paintings, explain why each scene attracted me and describe how I set about developing it. In the painting opposite, *Highland Fishing Village,* the sky was overcast and threatening, but there were breaks in the clouds and the sunlit whitewashed fishermen's cottages made a dramatic statement against the dark backdrop of mountains. The moored boats, the outcrop of rock and their reflections added interest to the foreground, while the gap in the harbour wall carried the eye to the pale expanse of sea and the distant mountains beyond. The dominant colour was grey and for this I used washes of French ultramarine and light red in various strengths. When used in a very liquid blend, these two colours tend to separate a little and this added interest to the cloudy sky. I included just a little harbour-side detail such as the lobster pots and the wooden planks, but kept the treatment as simple and direct as possible.

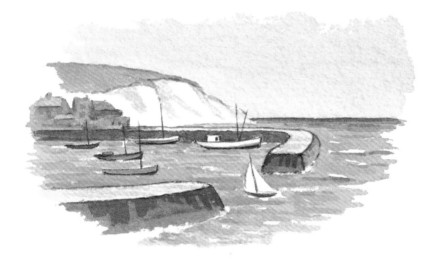

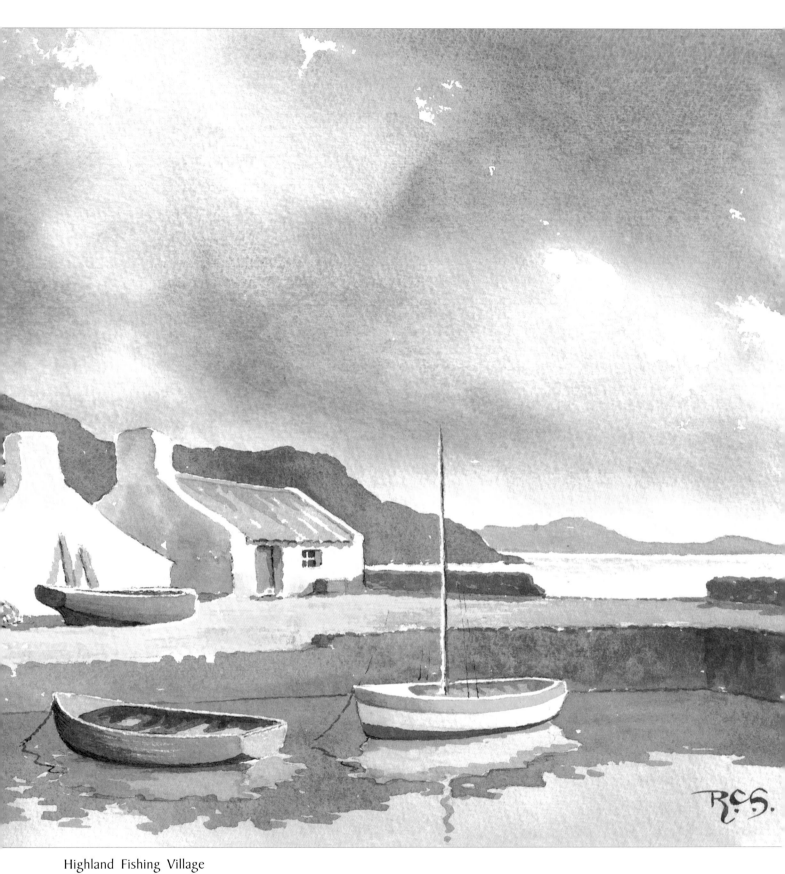

Highland Fishing Village

The painting, *Volondam*, (below) shows a typical Dutch harbour scene with brick buildings and stepped gable ends. The white painted house in the centre and the church spire both break up the line of red brick buildings and provide a little variety. The spire is perhaps a little too close to the centre of the paper for comfort, but the position of the foreground sailing barge, a more dominant vertical, is comfortably to the left of centre. Had the sun been shining directly on the buildings, they would have looked flat and uninteresting. Fortunately it was more to the left, and its lateral light produced shadows that gave the buildings a more three-dimensional effect.

Inner Harbour (opposite, top) shows how an oblique angle of view can produce a more pleasing composition and a more interesting pattern of tones and colours. The strong lateral light gave the jumbled cottages a three-dimensional appearance.

Welsh Harbour (opposite, below) was painted in the warm afternoon light. Here again the sun was to the left, and produced lateral shadows which gave the harbour-side buildings a feeling of solidity. The warm colour of the sky (raw sienna merging into light red, with a little French ultramarine and alizarin crimson) is reflected in the buildings and, more literally, in the water below. The stratus clouds were added, wet on dry, with a large brush held almost parallel to the paper to produce a slightly broken edge.

Volondam

The harbour-side buildings in this painting (below) made for a fairly busy passage with a lot of detail, so I decided to paint a very simple, clear sky and soft rather than hard-edged reflections.

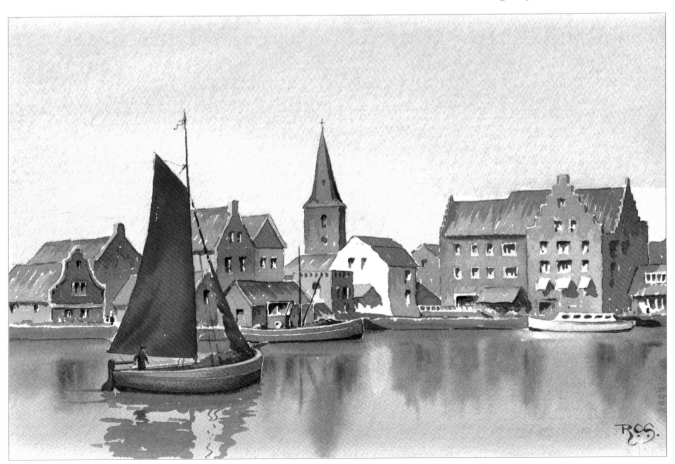

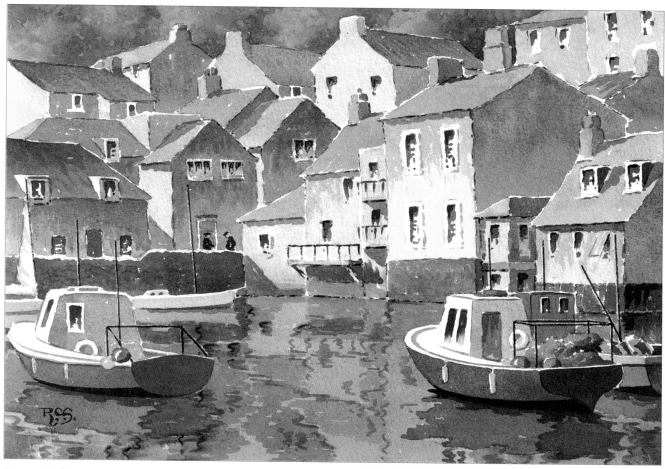

Inner Harbour

When the reflections were completely dry, I added a glazing wash of raw sienna and a little Winsor blue to the entire water area, to emphasise the local colour.

Welsh Harbour

Note the soft-edged reflections in the water: the busy scene does not need strong reflections.

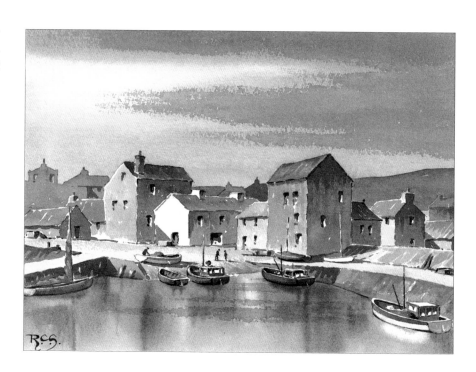

LANDING JETTIES AND BREAKWATERS

The term jetty has a somewhat loose meaning, covering almost any construction that projects into the sea. They are usually made of stone or wood and built so that boats are able to tie up alongside for the convenience of passengers and crew, and to assist loading and unloading. They often serve the additional function of sheltering stretches of water to provide a calm anchorage.

In the painting *The Whelk Sheds* (opposite), the jumble of sheds makes an interesting background to the calm harbour inlet. The reflections of the beached boat and the landing stage contain much of the greenish local colour of the water.

Breakwaters are normally simple but solid constructions of heavy baulks of timber, designed to protect beaches from the depredations of tides and coastal currents. When I painted *Breakwater* (opposite, below), which is also shown on the cover, I wanted to capture something of the pale silvery light of sky and sea, so I used deep tones for the shoreline to provide contrast. I used pale washes of French ultramarine and light red for my soft greys, with a hint of raw sienna for the warm glow in the lower sky and a little Winsor blue and raw sienna for the nearer waves. The breakwater was a much stronger wash of French ultramarine and light red, with an even deeper mix for the shadows. The shingly foreground was a broken wash of the same two colours with a higher proportion of light red, with a little calligraphy added with a brush to indicate a few pebbles.

The Solent
The sun's rays focus attention on the group of small boats, painted in deep tones on a patch of pale sea.

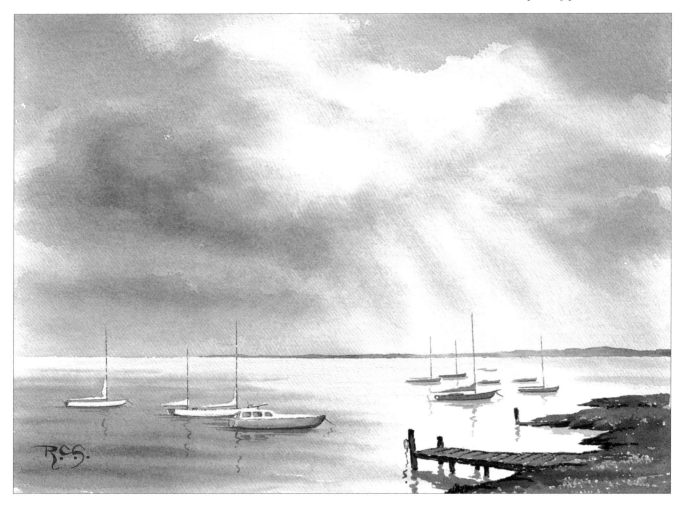

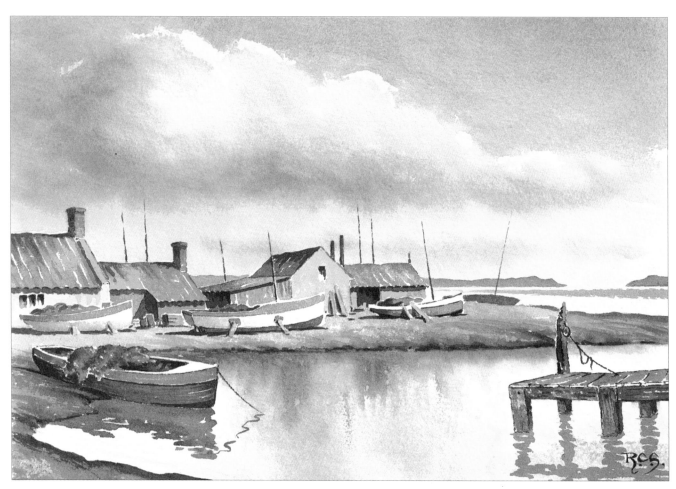

The Whelk Sheds

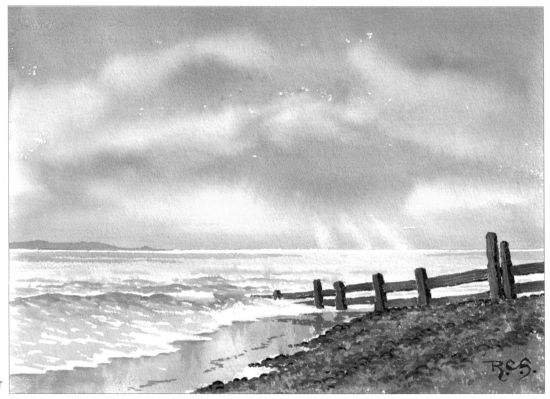

Breakwater

PIERS

Pleasure piers made their appearance in Victorian times when the seaside holiday was becoming increasingly popular, and coastal resorts vied with one another to attract visitors. Their elaborate designs were vulnerable to the ravages of storms and rough seas, but considering their highly-exposed positions, many have lasted surprisingly well – though not without considerable expenditure on repairs. Piers varied greatly in size and length. If coastal waters were shallow, and municipal funds plentiful, they might stretch half-a-mile out to sea, as at Southend. Some contained concert halls, bandstands and restaurants, while more modest piers boasted little more than ice-cream parlours and slot machines.

Not everyone finds a pier a paintable subject, but viewed almost in silhouette against a warm evening sky, they have a certain appeal. It was in just such conditions that I painted this impression. My main object was to capture something of the brilliance and shine of the evening sky, and its reflection in the calm sea. The area of radiance was simply the white of the paper, merging softly into the surrounding washes. These were raw sienna and light red, with French ultramarine, light red and a touch of alizarin crimson for the area above the horizon and the soft clouds, which I dropped in, wet-in-wet. I noticed that the section of pier against the area of brilliance looked much paler and warmer than the rest, and I tried to paint exactly what I saw.

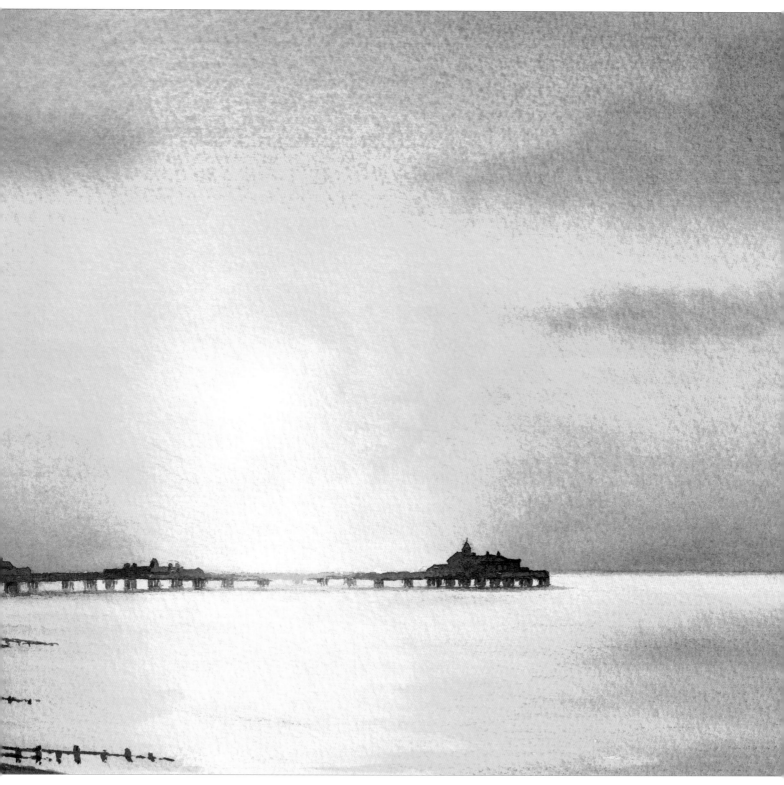

Pier at Evening

LOST HORIZON

The sea is often at its most paintable when mist draws a veil over the horizon and boats appear to be floating in the soft air. Watercolour is the perfect medium for capturing these ethereal effects, and we should always try to record them while their magic is still fresh in our minds. It is one of the mysteries of watercolour that quick, spontaneous impulse paintings are usually more effective than those that have been laboured over, particularly when trying to capture the effects of light.

I painted this picture from the recent memory of a windless, misty day when there were hints of sunlight behind the shroud of mist and the sea was a flat calm. Before applying the washes, I cut out three sail-shaped triangles of masking tape and stuck them to my paper. Although it was a quick, simple painting, I felt that it captured something of the impression the scene had made on me.

Full advantage should be taken of the medium's ability to reflect light and atmosphere, and capturing these vital qualities should be our primary aim – at the expense, if necessary, of accuracy and detail. Inexperienced watercolourists often alter paintings to correct mistakes, forgetting that what they gain in accuracy they more than lose in freshness and transparency. When mud rears its ugly head, the charm of the medium has already departed.

Lost Horizon

The dominant colour was a soft, blue-grey, for which I normally use French ultramarine and light red. As French ultramarine has a tendency to granulate on rough paper, in this case a 640gsm (300lb) rough watercolour paper, and I wanted the smoothest effect, I used a pale blend of Payne's gray and alizarin crimson, with a little soft raw sienna for the hints of sunlight behind the mist. My washes were applied with mainly vertical strokes of a large brush, over both sea and sky, which were virtually the same colour. I left everything to dry, then drew in a group of sailing barges using an old sketch book for reference. The silhouetted, distant boat on the right was painted with a stronger blend of Payne's gray and alizarin crimson, with a softer version for its reflection. The same wash was used to modify the local colours of the nearer group. Here, the reflections took their colour from the sea where it was not reflecting the bright tones of the sky, and I used Payne's gray with a touch of raw sienna. The sails of the little boats on the left needed soft reflections, and I used a small bristle brush to remove a small, soft-edged area of pigment below each of them.

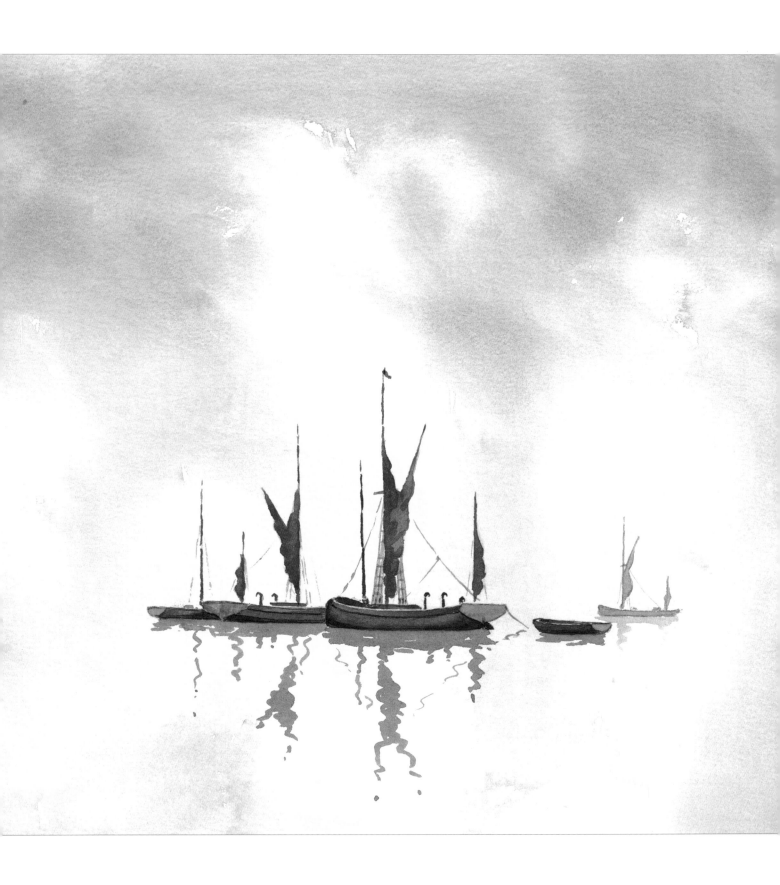

Chalk Cliffs

Where the North and the South Downs
meet the sea, steep, chalk cliffs result. In
the sunlight, their shining whiteness is
startling and I determined to emphasise
it in my quick watercolour impression.
As when painting snow scenes, the trick
is to make the sky very dark and the
striking tonal contrast that results will
do the rest. The sunlit chalk was just the
white of the paper.

For this simple treatment I needed just
four colours: two blues (Winsor blue
and French ultramarine); raw sienna and
light red.

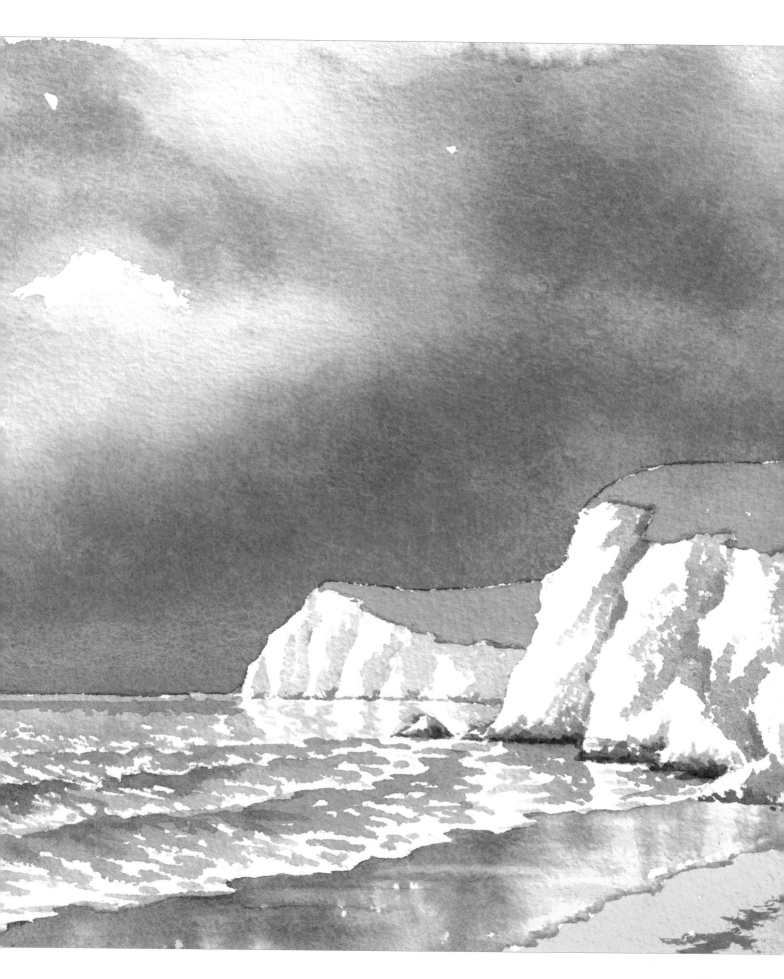

1 With a 2B pencil, sketch in the main construction lines of the scene lightly.

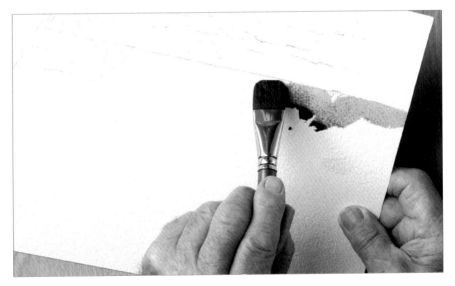

I began by preparing three washes for the sky:

1) *Ultramarine with light red (for the main area of cloud shadow)*

2) *Dilute raw sienna (for the sunlit areas of cloud)*

3) *Payne's gray with a little French ultramarine (for the upper sky)*

2 Rotate the paper 180° and put in a blue-grey wash, using the flat brush and painting carefully round the distant sailing boats and the chalk cliffs.

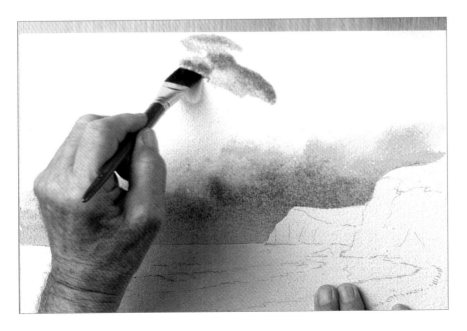

3 Add areas of the same French ultramarine and light red wash to delineate cloud forms.

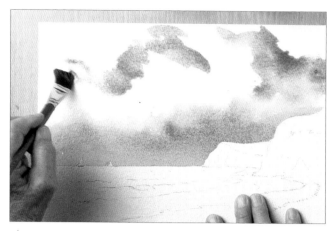

4 Drop in, wet-in-wet, the Payne's gray and French ultramarine wash to the upper sky.

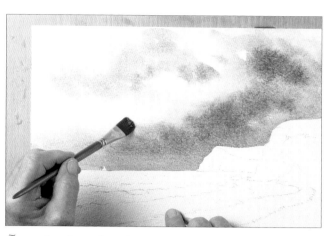

5 With a large brush dipped in clean water establish some areas of lighter cloud.

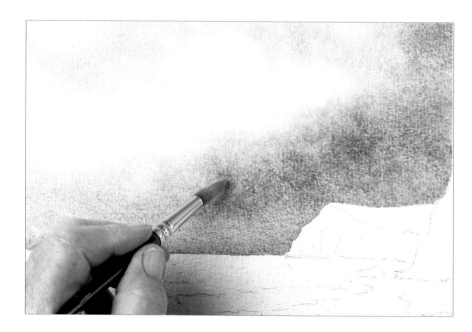

6 Change to the No.10 round Soften the edges between the pale and the dark areas of sky. Drop in more of the first wash close to the cliffs to increase the tonal contrast.

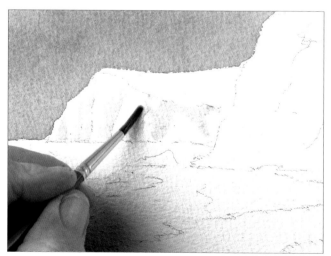

7 Change to the No.6 brush and paint in the shadows in the chalk of the far cliff with a pale wash of French ultramarine and a little light red.

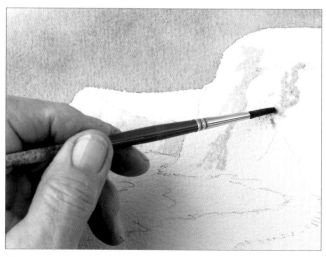

8 Repeat the process with the nearer cliff, using a stronger version of the same wash.

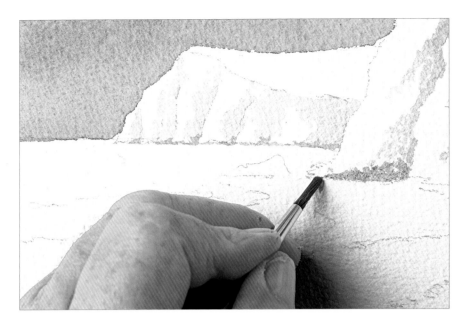

9 Add some green made from raw sienna with a little Winsor blue at the bottom of the cliff, to represent seaweed.

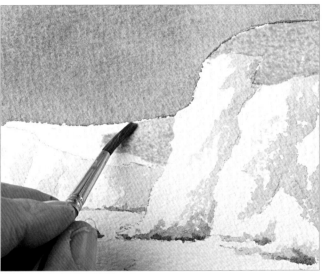

10 Using a wash of raw sienna and a little Winsor blue, put in the short downland turf.

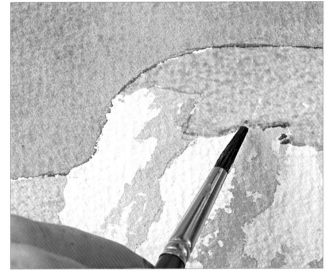

11 Define the cliff edge with a slightly darker tone using the green wash with a little Payne's gray.

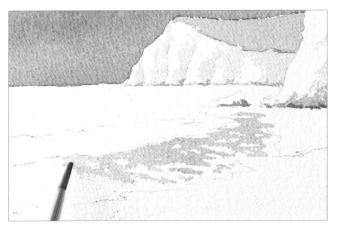

12 Using the same green mix, put in the nearer waves, leaving white paper for the areas of foam.

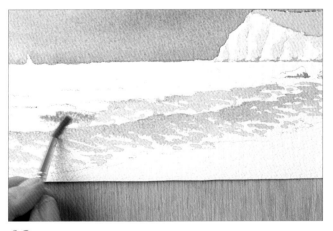

13 Add a little Payne's gray to the mix and put in shadow where the waves become steeper. Continue adding waves using the green mix.

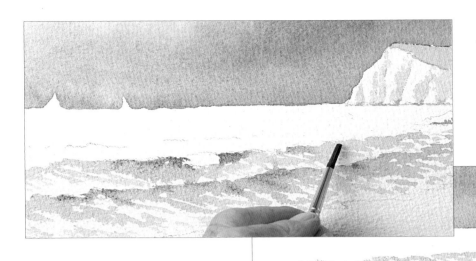

14 Continue to add shadow where necessary to vary the tones of the waves.

15 Paint in the distant waves more loosely.

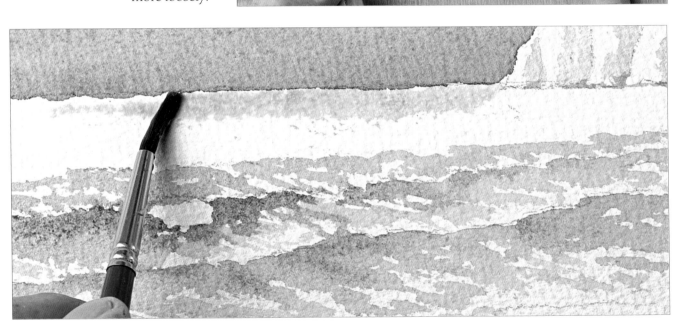

16 Increase the proportion of Winsor blue in the mix and put in the distant area of sea.

17 Finish painting in the more distant waves.

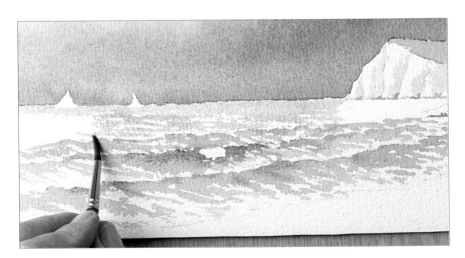

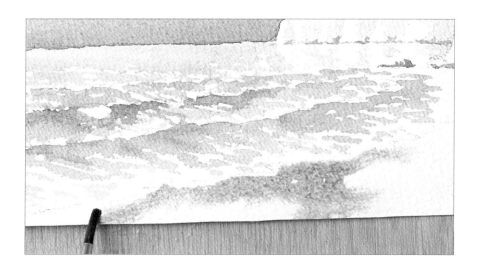

18 Paint in the strip of wet sand using raw sienna, and add the grey reflections wet-in-wet with French ultramarine and a little light red.

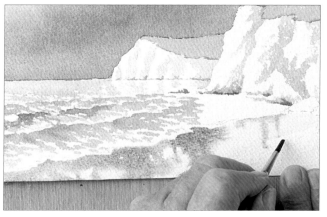

19 Start to put in the pale reflections of the cliffs in the strip of wet sand.

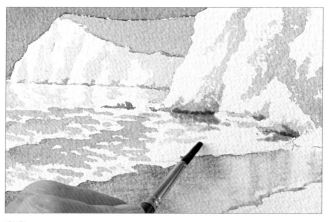

20 Complete the reflections of the cliffs in the sea.

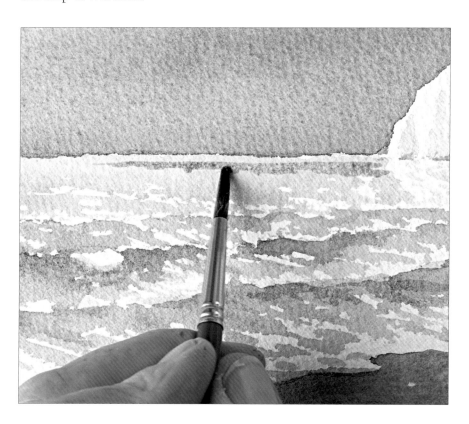

21 Add a foreshortened area of cloud shadow close to the horizon using a mix of French ultramarine with a little light red.

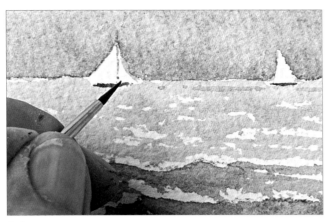

22 Using a darker version of the same mixture, put in the hulls of the distant sailing boats.

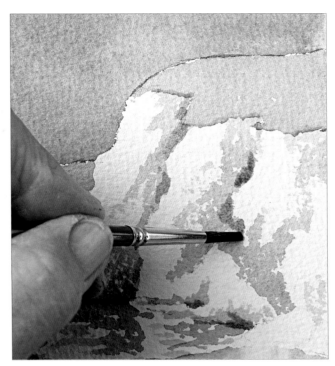

23 Increase the concentration of pigment in the shadow mix and add some more shadow detail to the nearer cliffs.

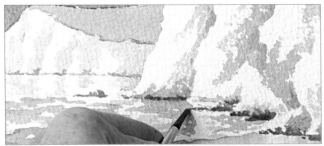

24 Strengthen the line of seaweed at the foot of the cliffs, using raw sienna and Winsor blue.

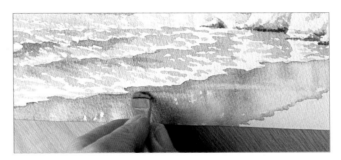

25 Add a little more shadow under the line of foam of the spent wave, using pale French ultramarine with a little light red.

26 Add a 'tide line' – a line of seaweed and detritus which marks the extent of the previous high tide – using a mix of Payne's gray and raw sienna.

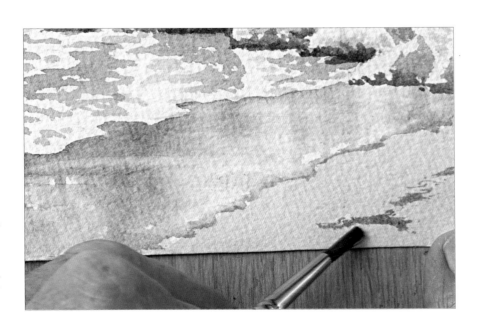

Fishing Village

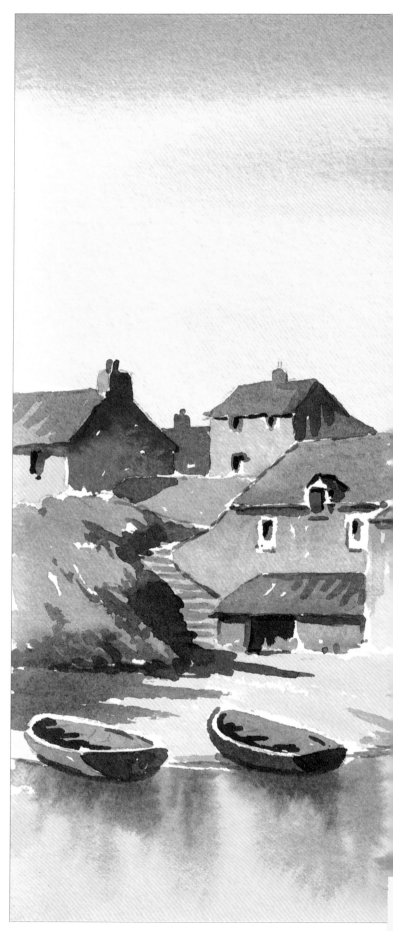

My subject here is a small West Country fishing village with its tumbled cottages fringing the harbour and the expanse of smooth water below; the whole bathed in mellow late afternoon sunlight.

I began by sketching in the main lines of the composition quickly with a 2B pencil. The scene was a fairly busy one, so I decided to use smooth washes for the warm coloured sky, with a soft-edged suggestion of stratus cloud. For the same reason, I planned a soft, wet-in-wet treatment of the calm water of the harbour.

I decided to make the most of the colour variations in the old buildings, and to do full justice to the deep shadows cast by the strong evening sunlight, to add interest to the scene and to achieve a three-dimensional effect.

I hope you find some of the suggestions in this book helpful, and that you will be encouraged to experiment with them, and perhaps to try out new ideas of your own. When you stop experimenting with new techniques and fresh subjects, and play for safety by sticking to what you know you can do, progress ceases and painting loses its excitement. Experiments do not always work, but those which do are a giant step forward!

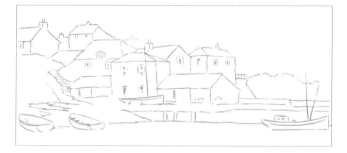

Preliminary sketch

Sketch out the main features of the composition using a 2B pencil.

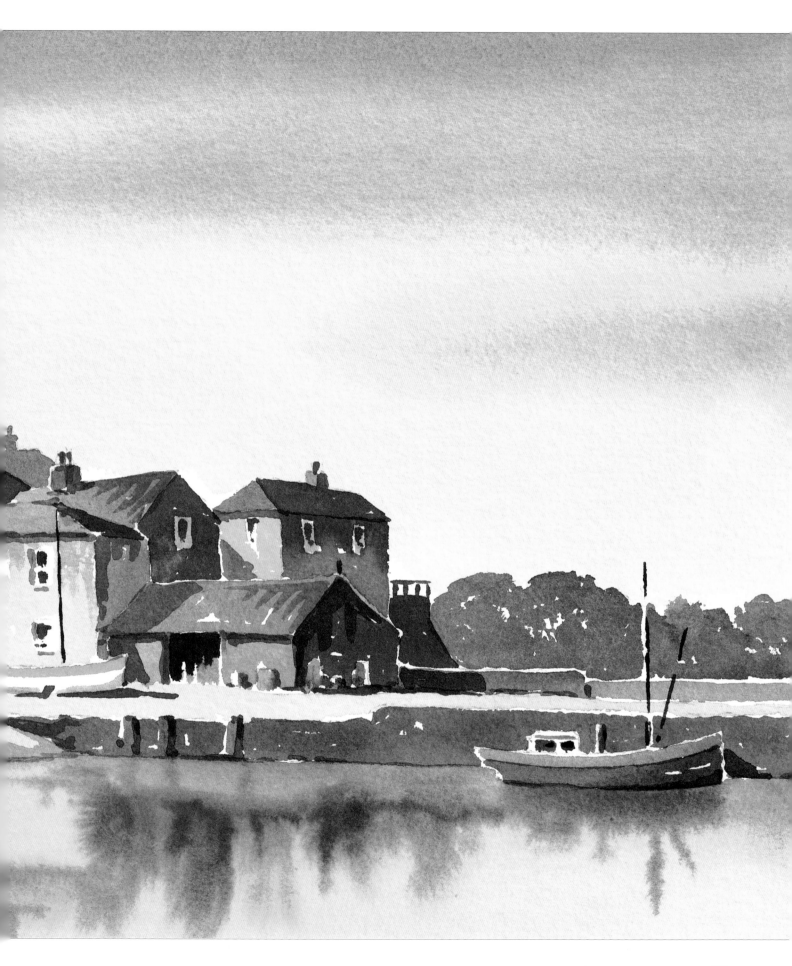

I began by preparing the two washes for the sky:

1) *Raw sienna with a little light red (base wash)*
2) *French ultramarine and light red (for the areas of cloud)*

1 Sketch in a few compositional lines with a 2B pencil. Using the flat brush, apply a wash of raw sienna with a little light red right down to the water's edge, to establish the warm evening light.

2 Remove some of the wet wash with a dryish brush, so that the boat and the window frames are white with just a touch of warmth.

3 While the sky is still wet, paint in some horizontal layers of soft-edged cloud, using a mixture of French ultramarine and light red.

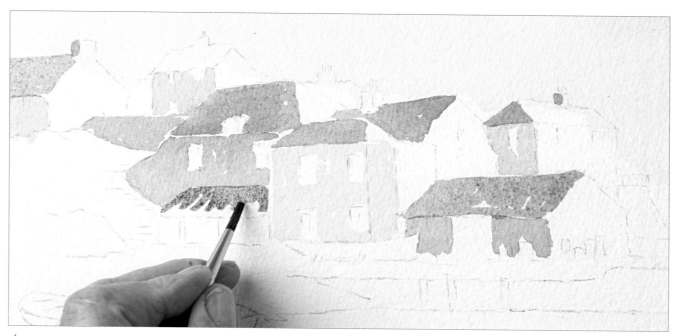

4 Change to the No. 8 round brush. Working from light to dark and using a variety of appropriate colours, begin to paint in the sunlit elevations of the waterfront cottages.

5 Let the pale washes dry, then begin to establish the shadowed elevations in much deeper tones, using the same colours plus some French ultramarine and light red.

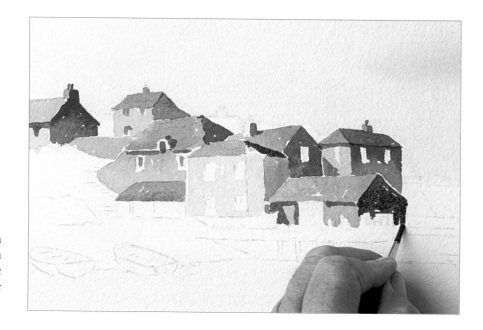

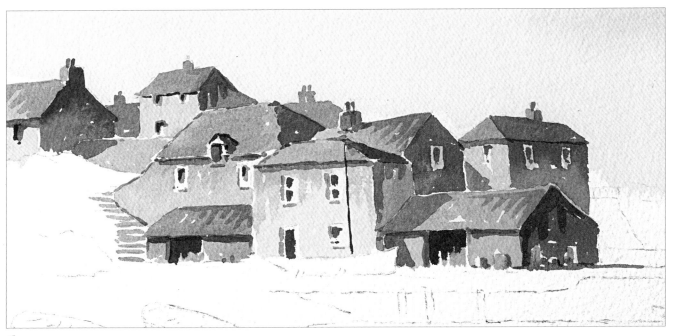

6 Begin to add details including
windows, doors and stone steps.

7 Change to the No.10 round brush
and put in the outcrop of rock using
burnt umber, adding a little green wash
at the base to suggest a growth of
marine algae and seaweed.

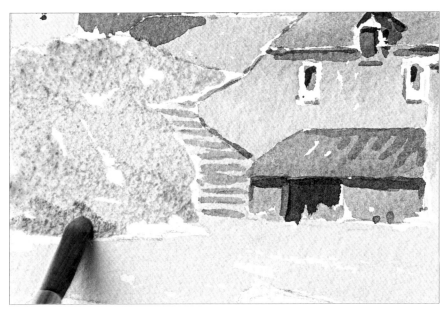

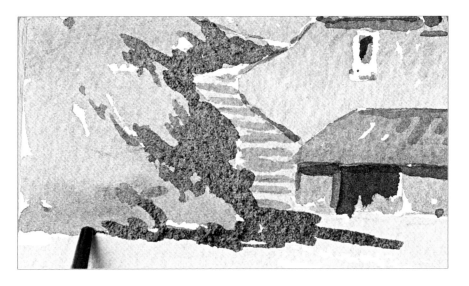

8 Change to the No.8 round brush
and put in the heavy shadows, wet on
dry, using a mix made by adding
French ultramarine to burnt umber.

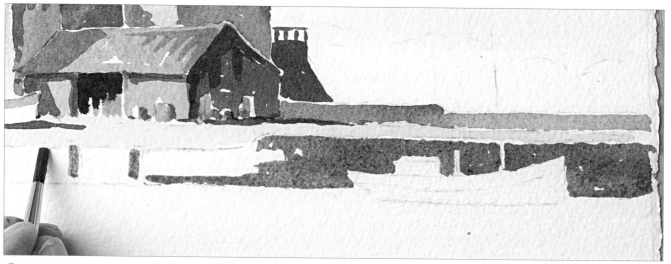

9 Put in the sea wall using burnt sienna and French ultramarine, with a little green added lower down. Emphasise the vertical baulks of timber.

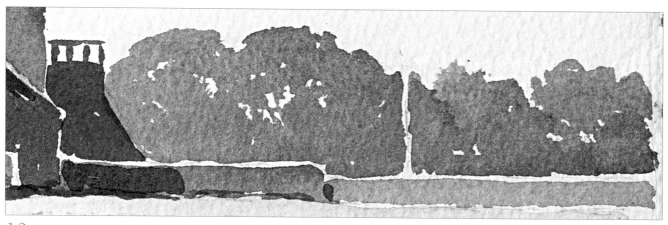

10 Change to the No.10 brush and put in the distant trees using a wash of French ultramarine with a touch of light red, applied with the side of the brush to capture their broken outlines.

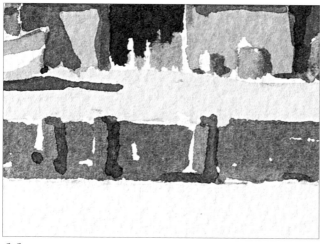

11 Change to the No.8 brush and add shadows to the baulks of timber using a mix of French ultramarine and light red.

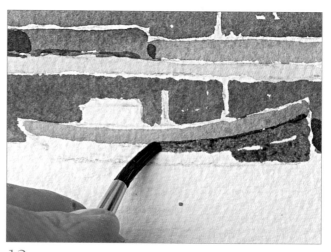

12 Paint the stripe on the boat in Winsor blue and the lower hull with a mix of burnt sienna and a little French ultramarine.

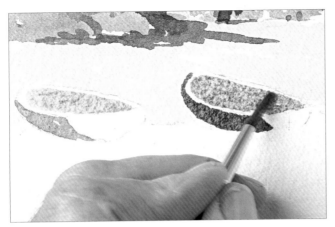

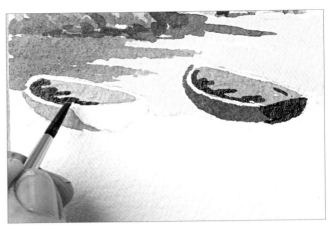

13 Paint in the beached boats using burnt sienna, and burnt sienna with a little French ultramarine added.

14 Using a much deeper mix of the same colours, paint in the shadows. Leave the tops of the gunwales untouched.

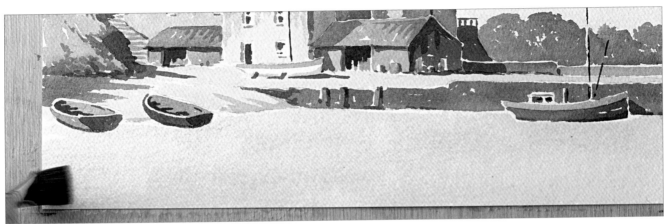

15 Using the flat brush, apply an even wash of raw sienna and a little light red to the whole of the water area.

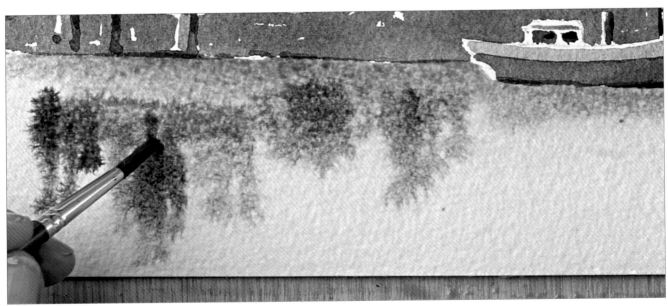

16 While the base wash is still wet and using vertical strokes, begin to drop in the tones and colours of the objects being reflected.

94

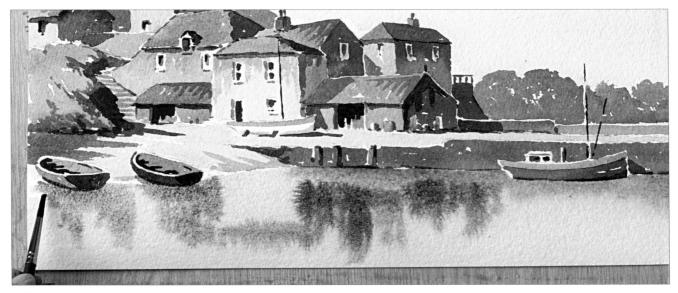

17 Still working wet-in-wet, add a few more vertical dark accents to the reflections.

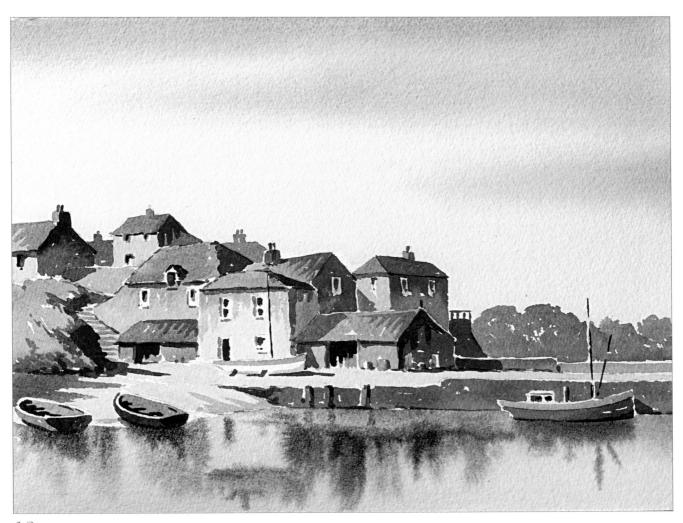

18 Sharpen up the detail where necessary, until you are satisfied with the result.

Index

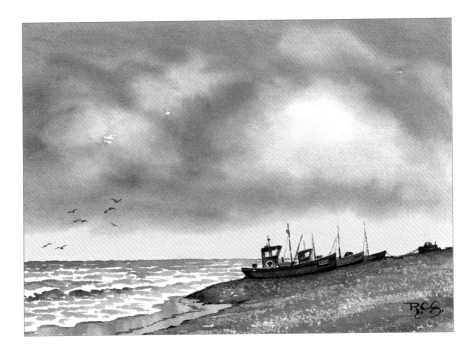

Beached Fishing Boats

*A lively and interesting sky
justifies a low horizon.*